FAIRFIELD

THROUGH TIME

To Dave,
Enjoy the sights and
sounds of our favorite
city!
Scott Fowler
Dec 2017

SCOTT E. FOWLER

AMERICA
THROUGH TIME®
ADDING COLOR TO AMERICAN HISTORY

DEDICATION

This book is dedicated to the memory of the late Esther Benzing who influenced a variety of young and old readers to appreciate and preserve local history through her abundant newspaper articles and two books dedicated to the history of Fairfield and Fairfield Township.

AMERICA THROUGH TIME is an imprint of Fonthill Media LLC

First published 2016

Copyright © Scott E. Fowler

ISBN 978-1-63500-026-9

Typeset in Mrs Eaves XL Serif Narrow
Printed and bound by CPI Group (UK) Ltd, Croydon, CR0 4YY

Published by Arcadia Publishing by arrangement with Fonthill Media LLC
For all general information, please contact Arcadia Publishing:
Telephone: 843-853-2070
Fax: 843-853-0044
E-mail: sales@arcadiapublishing.com
For customer service and orders:
Toll-Free 1-888-313-2665

Visit us on the internet at www.arcadiapublishing.com

INTRODUCTION

The City of Fairfield can trace its roots to the early 1950s, prior to becoming a city, when the City of Hamilton was initiating efforts to incorporate a large chunk of what was then Fairfield Township. But the history of this southwest Ohio city actually dates back almost 200 years. The City of Fairfield was originally part of the legendary Symmes Purchase, a small but major real estate transaction that resulted in the establishment of a major US city and led to a population outbreak that helped inaugurate statehood for Ohio.

The Symmes Purchase goes back to 1788, when New Jersey Congressman and judge John Cleves Symmes formed a company to purchase land in the Northwest Territory between the Great Miami and Little Miami Rivers from the US Government. Symmes requested one million acres of land from Congress but was granted about 330,000 acres that ran from the Ohio River up to just north of what is today Warren County. President George Washington approved the land patent in 1794 for the price of sixty-seven cents per acre. Part of the stipulation of the purchase included that land be set aside for schools and churches.

A number of settlements sprang up, including Hamilton and a small community along the Ohio River referred to as Losantiville, which later was renamed Cincinnati. Symmes developed his personal survey process and discarded the US Government survey system that had been established years earlier that was based on the location of rivers, stones, and natural boundaries. Symmes identified his surveys by naming towns, ranges and sections that simplified descriptions. Symmes survey became only the second locality in the world to use such a system.

Symmes also sold land beyond the boundaries of the original purchase that resulted in land owners finding themselves trespassing on their own land and were required to repurchase it from the government. Symmes' disregard of the existing land grant system forced Congress to restrict the size and scope of future land sales to private real estate speculators and arranged its own land surveys.

After Ohio became a state in 1803, Fairfield Township became one of the original townships in Butler County when it was formed on March 24, 1803. Through the years, pieces of the township were annexed by the City of Hamilton, which served as the county seat. Development in Fairfield Township remained stagnant since it was primarily a rural community except in the southern portion bordered by Hamilton County.

In the south region of the township, unincorporated areas such as Stockton (Jones's Station), Fairplay (Black Bottom), Symmes Corner and Furmandale became popular villages and stops for travelers. The old Dixie Highway was taken over by the state and transitioned into State Route 4.

Mt. Pleasant Pike was renamed Pleasant Avenue by the locals and State Route 127 by the state. Both former toll road routes provided quick access to Hamilton, Cincinnati and Middletown, among other areas.

By the early 1950s, Hamilton's population was just under 60,000 and growing but the city was running out of land and needed to expand its tax base. City leaders targeted the southern and western portions of Fairfield Township for annexation.

In 1953 Fairfield Township residents Gilbert E. "Gus" Condo, Carl Kollstedt, and Robert Wessel began to investigate the feasibility of establishing a village that would stop Hamilton's efforts to annex almost half of the township. Hamilton ultimately wanted the General Motors/Fisher Body plant on State Route 4, which provided over half of the township's funding. The trio were quickly joined by Winifred Field, Walter Hunter, Keith Faist, Jr., Warren Harding and Warren Steele.

The group focused their efforts on informing township residents on the proposed annexation and expanded its committee to include Marguerite Burkett, Carrie Burnett, Dr. Arthur Schalk, John Slade, Helen Wessel, Joseph and Grace Hoelle and members of the Fairfield Resident's Association. An initial vote to incorporate the entire township failed since many of the residents felt that farms did not belong within city limits. The initiative was brought back to voters with a renewed focus at the more populated areas located in the southern portion of the township. Their efforts succeeded and the Village of Fairfield was created July 10, 1954.

During the months following, efforts were made to attach the unincorporated area of Stockton in the southern-most portion of the township to the village. Stockton's location was within a couple miles of the Hamilton County border and State Route 4 ran through the area making it a very desirable area to develop. Stockton voters saw the advantages of becoming part of a village and approved the effort in early 1955. The additional residents pushed the population of the village over the required number to become a city. The state recognized Fairfield as the state's newest city on October 20, 1955.

With a population of just over 6,200, the city had very little financial resources available to serve residents. Fairfield Township was forced to give up ownership of a fire house on Pleasant Avenue and two emergency vehicles to the new city.

The first elected city council were given the oath of office on December 27, 1955 by Butler County Common Pleas Court Judge P. P. Boli who acted as a "godfather" to the new city. Council members included Ben Groh, Merle J. Daughtery, Francis L. Miller, Charles Vance, William Holden, Walter Hunter, Ellis Muskopf and Mayor Robert Wessel.

On February 13, 1956 a gas franchise was awarded to the Cincinnati Gas & Electric Company (now known as Duke Energy) and a million and a half dollar plan was passed by council that provided the majority of the city with safe, clean water and adequate fire

protection. Within the next few years, the city established a street department, obtained a US Post Office, constructed a state-of-art municipal building and partnered with the Lane Public Library system to construct a branch within the city. By the early 1970s the Parks Department expanded rapidly and hired its first full-time director.

One of the most significant acquisitions the city made was the purchase of the Hunter/McDonald farm located on Pleasant Avenue that enabled the city to create a 160-acre park for a variety of activities. In the late 1970s, the city purchased an existing golf course and developed an aquatics center adjacent to it.

In addition to the city's efforts, the state expanded State Route 4 to four lanes in 1962 and connected the road to I-275 which opened just south of the city in 1968. Bypass 4 opened in 1970 and helped alleviate traffic congestion along State Route 4.

In the 1980s, Pleasant Avenue and Nilles Road were widened. In 2001 the city was connected to I-75 with the opening of the Symmes Road/Union Centre Boulevard connector.

The city's population ballooned as housing developments quickly engulfed family farms throughout the city. The Fairfield City School District, which also services all of Fairfield Township, added three elementary schools and three upper level schools throughout the city and township to address growing student population.

In 1993 Fairfield Township officials approached the city to discuss a possible merger due to annexation attempts by the City of Hamilton. A merger commission was approved by voters to develop a feasibility study. The study ended abruptly when the township sought to become the Village of Indian Springs. State courts overruled the township's attempt and the area resorted back to a township. Since that time, the city and township have worked closely on issues involving the Fairfield City Schools, By-Pass 4, and residential and commercial development along their shared borders in the north section of the city.

In 2015 the City of Fairfield has a diverse population of over 42,000 and encompasses over twenty-one square miles. The city is home to the world-renowned Jungle Jim's International Market, the Cincinnati Financial Corporation, the Ohio Casualty/Liberty Mutual Insurance Group, Medco Health Systems, Koch Foods, Pacific Industries, M. Bohlke Veneer Company, and the Western States Machine Company, among others.

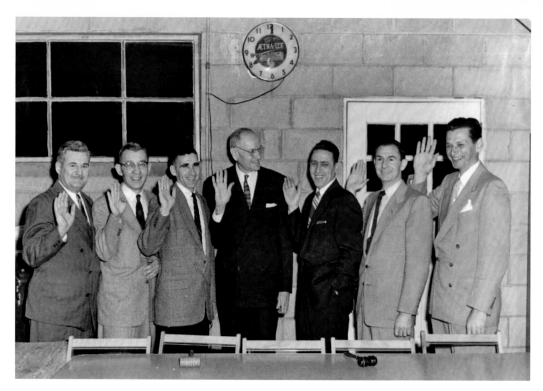

CITY COUNCILS, SIXTY YEARS APART: The first elected council didn't take office until January 1, 1956. The group's first photo was taken inside the former Company 1 firehouse on Pleasant Avenue. From left to right: Ben Groh, Merle J. Daughtery, Francis J. Miller, Judge P. P. Boli, Charles Vance, William Holden and Walter Hunter. Also elected but not pictured were Mayor Robert Wessel, Clerk Grace Hoelle, Solicitor Carl Kollstedt, Treasurer Winifred Field, Council President Lawrence Lloyd, Sr. and Councilmember Ellis Muskopf. The 2015 council members from left to right front row: Bill Woeste, Mayor Steve Miller and Vice Mayor Debbie Pennington; back row: Terry Senger, Marty Judd, Chad Oberson, Mike Snyder and Adam Jones.

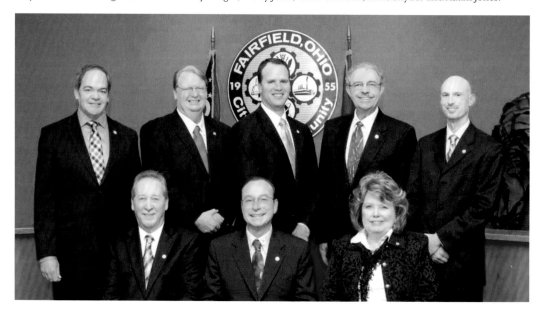

CONTENTS

ACKNOWLEDGEMENTS

Many local historians, notably Esther Benzing, John Slade, Robert and Helen Wessel, Lois Kingsley, Howard Dirksen, Edna Antes and Dan Finfrock, have documented a variety of city history in word and images. Their contributions over the past sixty years were not only interesting to research but provided a clearer understanding of our history. Despite Fairfield's rapid growth to become one of the most desired places to work, play and live, the importance of our past was never lost thanks to our local historians.

A special acknowledgement goes out to Bob Pendergrass, the archivist for the Fairfield Historical Society. Bob's relentless dedication and robust desire to preserve anything dealing with the City of Fairfield has resulted in an expansive library of historic photos, letters, books and other artifacts related to Fairfield. Bob is a walking encyclopedia of local history and is always spending time researching, organizing photos and helping preserve our past.

Richard Piland provided countless photos from the Butler County Historical Society and conceived the initial plan to write an updated book on the city a few years ago. Richard has written several books on Butler County history and I always enjoy reading his material.

Archival photographs were provided by the Fairfield Historical Society, the Ohio Department of Transportation, Edna Antes/Fairfield Echo newspaper, the George Crout Collection/Middletown Library, the George Cummins Collection/Lane Public Library, Dean Langevin/Audio Visual Impact, Cindy Marsh, Bob Pendergrass, Robert Burer, the City of Fairfield, the Smith Library of Regional History, Dan Finfrock, Pete Groh, Nancy Hutton, Phyllis Hutton, Teresa Alexander, Steven Bacher, Sam Minnelli, Stephanie Adams/Jungle Jim's International Market, Tara Stroud, Lois Kingsley and Helen Lahmann and Rhonda Lahmann.

Thanks also goes out to Fairfield Historical Society President Debbie Pennington. Debbie worked behind the scenes to provide access to city resources and personnel in order to obtain information for this book. She has also been a great cheerleader not only for this book but for the city as a whole.

Finally, Alan Sutton and Heather Martino at Fonthill Media have been great to work with. Their patience and understanding that some of the photos, while very poor in quality, are the only eyes we have of the past.

CHAPTER ONE

SYMMES CORNER

SYMMES CORNER, EARLY 1900S: Symmes Corner was located in the vicinity of Pleasant Avenue and Nilles Road and was the most popular village in Fairfield Township during the late 1800s and early 1900s. The Trolley line played a major role in the village's popularity, which was also known as Symmes Corners (with the "s" added), Symmes City, Union Corners and Symmes. The village was founded by Celadon Symmes who bought the majority of the land from his uncle, John Cleves Symmes, in 1795. Numerous homes were built along Pleasant Avenue to the point where the village sustained its own post office during the mid-1800s and served as a major stopping point for the trolley.

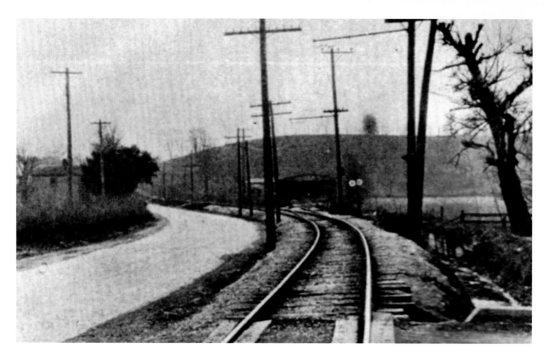

INTERURBAN TROLLEY LINES, PLEASANT AVENUE: The Cincinnati & Hamilton Electric Street Railway began in 1898 and ran along Pleasant Avenue every half hour. Ownership of the company changed fifteen times in forty-one years and experienced multiple name changes. The trolleys used electric-powered high speed rail cars that provided efficient and reliable transportation versus the dirt trails that dotted Fairfield Township. The powerhouse and car barn were located where Applebee's and PNC Bank are located today. The powerhouse was replaced in 1906 with a similar facility on River Road in Hamilton. By 1939 automobiles and buses replaced the trolleys and the line was abandoned.

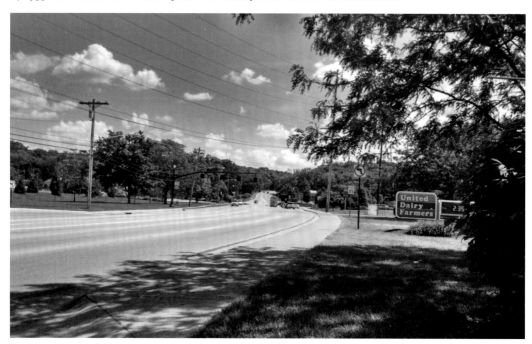

PLEASANT AVENUE COVERED BRIDGE, CROSSING MT. PLEASANT CREEK: Schoolteacher Bessie Kehm lived near one of the only covered bridges in Fairfield Township. Historian Esther Benzing suggested that the bridge may have been covered to preserve the bridge structure and provide a buffer from the trolley car line that ran parallel to the road. Kehm, who taught nearby at the Symmes Community Chapel and at Taylor School in Hamilton, posed for this picture around 1902. There was no documentation that indicated when the bridge was built. The bridge was replaced in 1934 as part of a major widening and paving project, which also removed a dangerous s-curve on Pleasant Avenue near the site of the current municipal building.

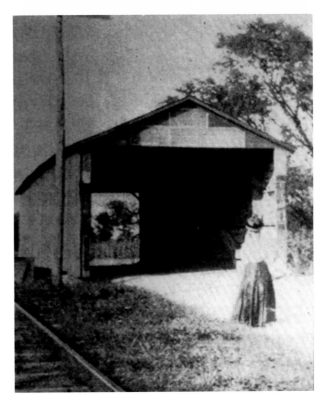

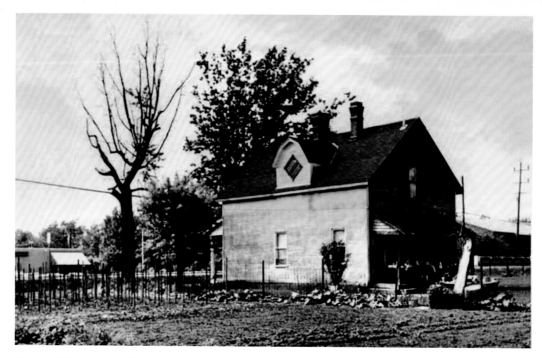

CREACH RESIDENCE, PLEASANT AVENUE: Several generations of the Creach family lived in the area that now encompasses Riegert Square and a host of commercial businesses. The home was one of the last residences to be torn down and sat next to a Photo Bug drive-thru during the 1970s. Although the home was not torn down until the mid-1980s, commercial development surrounded it as the Fair Plaza Shopping Center across the street opened in 1961, Riegert Square emerged in 1967 and Applecreek Apartments opened in 1970. In 2015, a Family Dollar store operates on the site.

AARON SYMMES RESIDENCE,
PLEASANT AVENUE: Shortly after
Fairfield became a city, efforts were
underway to tear down many of the
original homes along Pleasant Avenue
to make way for a commercial strip.
Symmes' descendant Aaron Symmes
was one of many family members who
purchased land from his uncle. The
Symmes Corner Market and Trailer
Park was located next door until the
late 1960s when Riegert Square was
developed. The construction served as
a spring board for other businesses to
be constructed along Pleasant Avenue.
In 2015 Gene's Resale Shop and H & R
Block Tax occupy the former Riegert
Furniture store, the anchor of the
shopping strip.

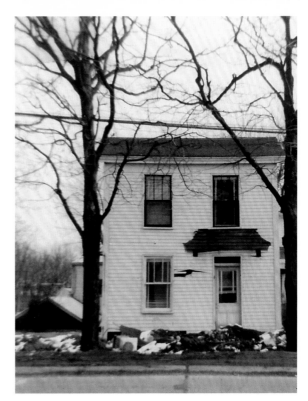

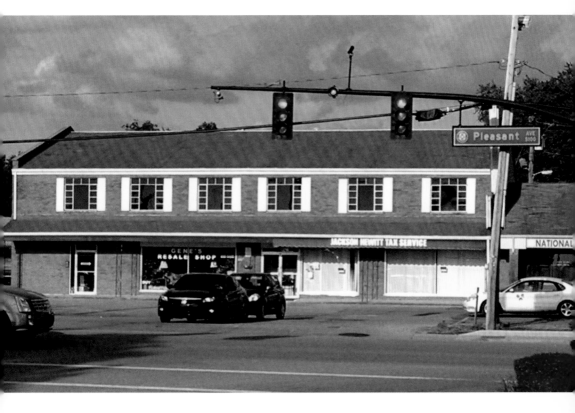

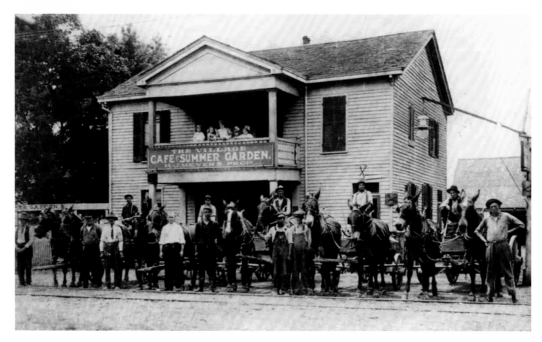

VILLAGE CAFÉ AND SUMMER GARDEN, PLEASANT AND NILLES: In 1914, Jacob and Mary Milder purchased the Village Café from H. J. Meyers and rechristened it Milder's Inn. During its twenty-eight years, Milder's was synonymous with "The Best in the Middle West" fried chicken and hosted clientele that included Cincinnati Reds players and business and social notables from the region. During the Prohibition era some of the region's most notorious bootleggers and rum runners patronized the spot. On May 27, 1929 Little Chicago gangster Turkey Joe Jacobs and Bob Zwick interrupted their meal at Milder's for a bloody rendezvous at River and Nilles Roads. Jacobs was killed, but Zwick, after being shot, returned to Milder's before fleeing the area.

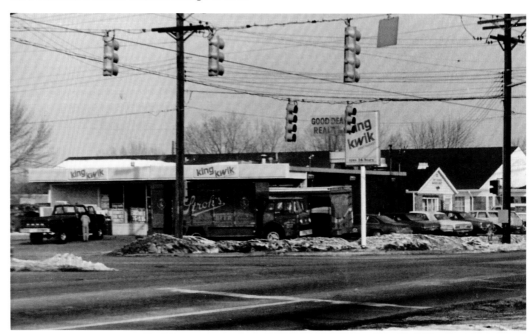

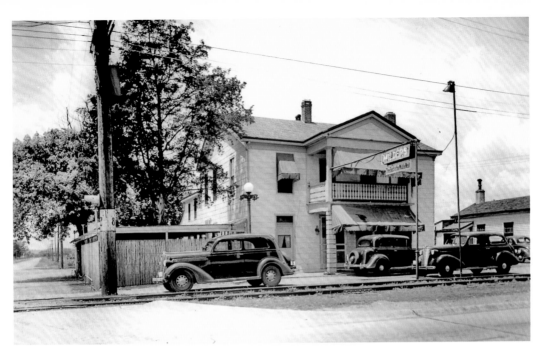

MILDER'S INN, SYMMES CORNER: After twenty-eight years of ownership, Milder's Inn closed in October 1942. The property and equipment were sold at auction the following month. The building was torn down in the late 1940s. In the late 1960s, a King Kwick convenient market was built on the site along with a medical facility and a barbershop. When King Kwick closed in the mid-1980s, the Chili Company moved into the building. As Village Green developed across the street, the site was razed and a CVS Pharmacy was built in 2001. Milder's Inn recipes are still used in 2015 at Ryan's Tavern in Hamilton, by Tully Milder, the great grandson of Jacob and Mary.

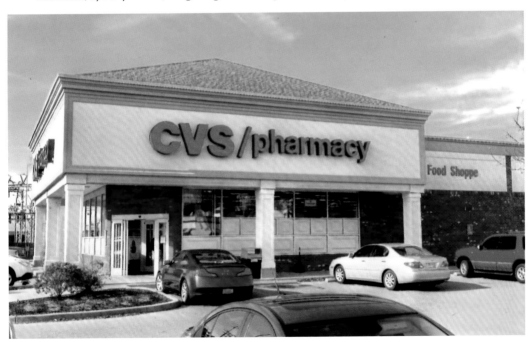

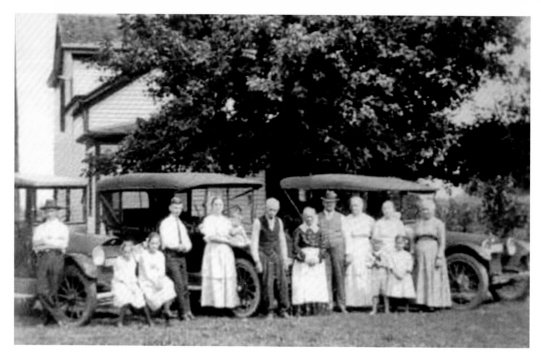

FAIR PLAZA SHOPPING CENTER, PATTERSON BOULEVARD: The Jacoby family farmed the land that eventually became the city's second shopping center. Fair Plaza opened in 1961 and featured a Marsh supermarket, Haag Drugs, Miracle Mart and an IGA as major anchors. The IGA was replaced by an Alber's supermarket but that store closed in the mid-1970s and replaced by a book store. Miracle Mart was replaced by Twin Fair (Meijer) shortly after it opened. By 2009 the center lost most of its tenants and most of the center was demolished and remains vacant. In 2010 the name of the center was changed to Patterson Place.

SECOND NATIONAL BANK, PATTERSON BOULEVARD: The view from the entrance of the Second National Bank included some of the township's past and the city's progress into the late 1960s. The Creach home can be seen across the street surrounded by Fair Plaza, Riegert Square and a new strip mall that would become the home of Jake's Pizza in the 1980s. Second National Bank was bought out by US Bank and continues to operate in 2015.

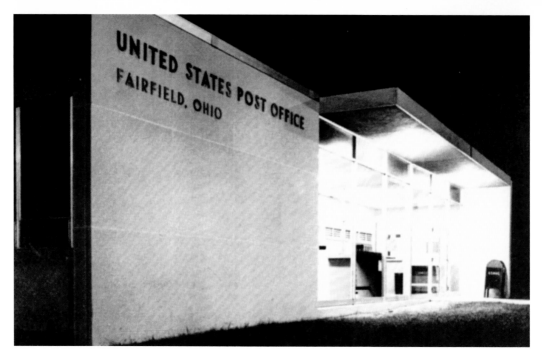

US POST OFFICE, PATTERSON BOULEVARD: Soon after Fairfield achieved city status, the fight was on to gain a full service post office. In 1962 that dream was achieved when the facility opened for business. As the city grew, space and the inability to expand became an issue during the 1970s and '80s. In 1990 the post office moved into a larger facility on Wessel Drive across from the Municipal Building. The original post office building didn't stay vacant long. It was purchased by the Veterans of Foreign Wars Post 1069 who were seeking a smaller venue than their existing building on Hicks Boulevard.

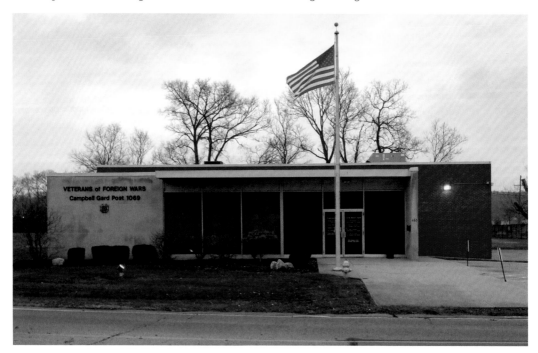

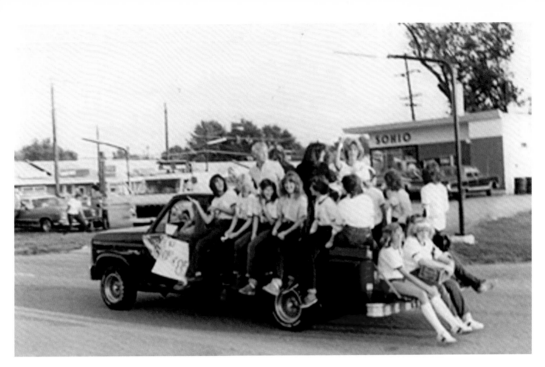

JIM BRASHEAR'S SOHIO, PLEASANT AND PATTERSON: The Sohio station on Pleasant Avenue at Patterson was not just your average gas station. Since 1961 owner Jim Brashear would pump gas, check the oil and tire pressure, while working on a car in one of his two service bays. The station morphed into a BP and continues to operate in 2015 as an independent convenient store and gas station. The station is located adjacent to the Fair Plaza Shopping Center and the site became a favorite spot to view homecoming parades like this one.

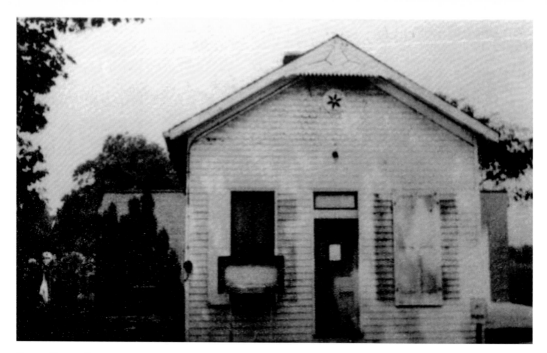

TOWN HALL, SYMMES CORNER: In 1890, Fairfield Township built a meeting hall on a lot purchased from Henry Kehm. The structure was illuminated with an oil lamp and heated by a stove and served as a municipal building when Fairfield became a village in 1954. It was torn down in 1958 when an addition was added on to the Company 1 firehouse and served as the municipal building. The building continued to serve as a firehouse and city annex offices when the current municipal building opened in 1965. The firehouse was sold in 1990 after the fire department moved to a larger facility. A 250 year old oak tree still stands guard over area where the original building once stood.

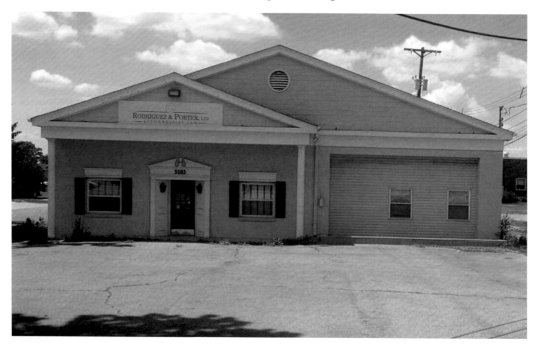

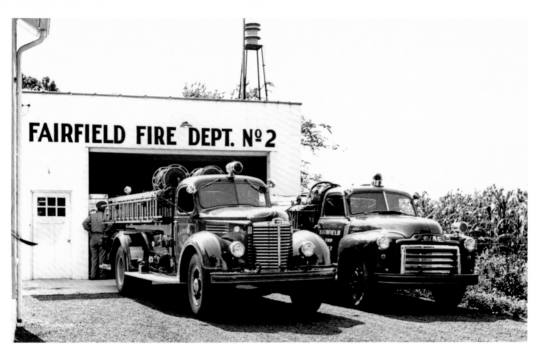

FAIRFIELD FIRE DEPARTMENT, COMPANY 1 FIREHOUSE: Built just prior to the city becoming a village, Company 2 was just large enough to house two fire trucks. The name of the firehouse was changed to Company 1 and the building was expanded to serve as a municipal building. In 1962, Station 2 was built on State Route 4. In 1978 a third station was added on Winton Road. A decade later the volunteer staff was replaced with part and full-time fire fighters available around the clock at all three stations, including the new fire headquarters on Nilles Road that replaced Company 1. By 2000 a new station was built to replace the station on State Route 4.

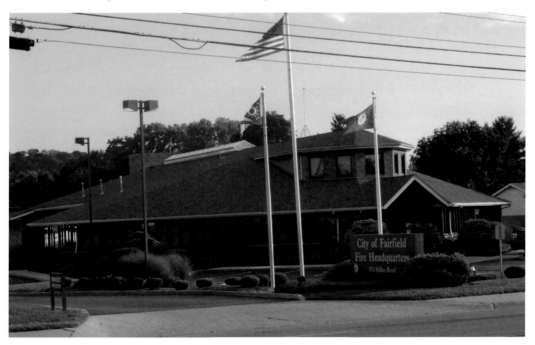

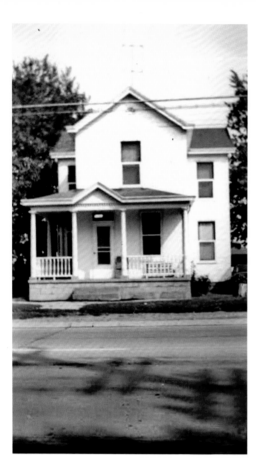

MOSS RESIDENCE, PLEASANT AVENUE: Harmon Moss left the front door of his home thousands of times not knowing if he would return to his family. Moss served as Fairfield's fire chief from 1956-1965 and was assistant chief prior to that. Living across the street from the firehouse, Moss often fielded the call for assistance from his home and then ran to the firehouse to activate the audible siren to signal the volunteer fireman to respond. Fairfield's first home improvement center, Cost-Rite, was built on the site in 1975. In 2015 the space is divided among Bee's Driving School, Fairfield Framing, the Donut Spot and Nails 2000.

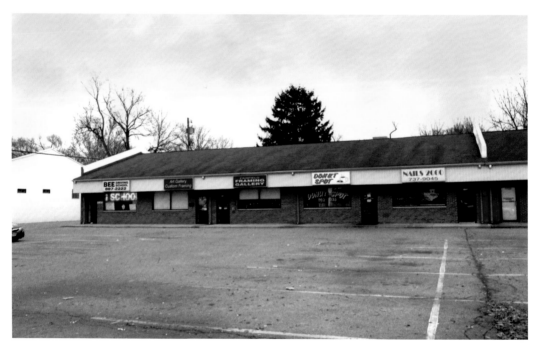

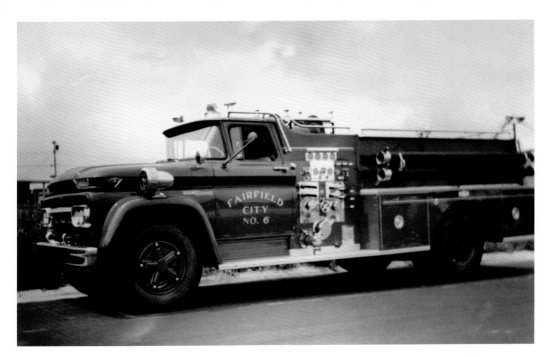

FAIRFIELD FIRE APPARATUS: This *circa* 1960 GMC fire pumper was one of the first pieces of fire apparatus purchased by the city. Through the years, this engine participated in some of the city's major fires, including the 1967 Bright-O Metal Products fire, the 1973 Wildwood Country Club fire, the 1976 Arnold Graphics fire and the 1967 Groh Farm plane crash that killed five people. In 2015 this E-One pumper/ aerial combination truck with a seventy-five foot aerial ladder is one of three pieces of apparatus the department has at each of its three stations along with a mobile command unit, a fire prevention lab vehicle and other fire apparatus.

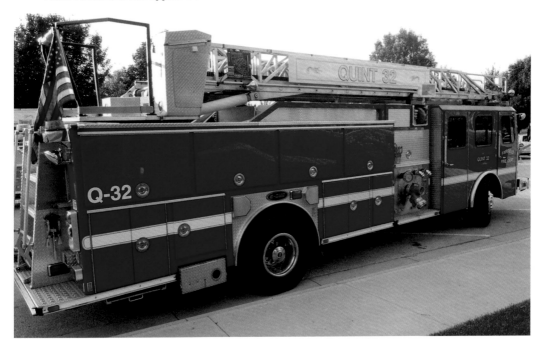

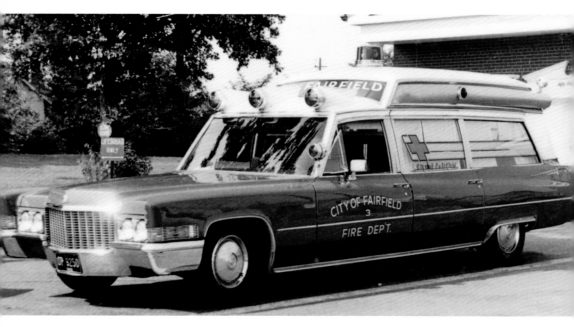

Fairfield Fire Department Paramedic Unit: The fire department has provided ambulance services since the 1956 police cruisers were station wagons equipped with stretchers. This 1970 Cadillac life squad was one of two used in the city during the 1970s by firemen. In 2015 a 24-hour paramedic unit serves the city, utilizing three Horton modular ambulances equipped with advanced life support equipment and utilizes a bicycle patrol at special events.

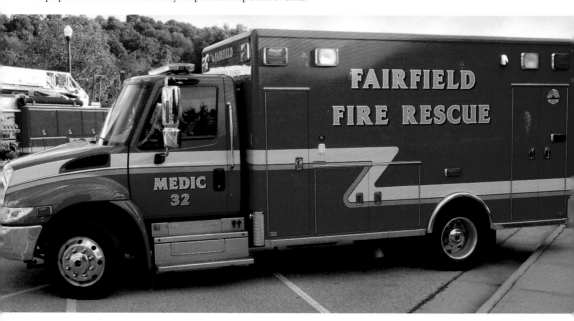

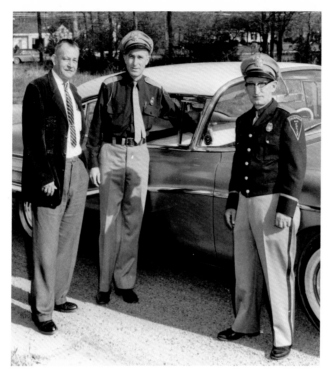

FAIRFIELD POLICE DEPARTMENT: In the city's early days, Police Chief Charles Hawkins was the only employee when he took office in July 1956. He drove a 1956 Chevrolet station wagon equipped with a stretcher and two-way radio and dispatched through the Butler County Sheriff's Office. The police department has evolved into a professional accredited department of over sixty police officers, a K-9 unit, a park ranger division and a state-of-the-art dispatch center located in the Fairfield Justice Center across from Village Green. 2014 Ford Police Interceptor all-wheel drive utility vehicles are the newest additions to the department's fleet.

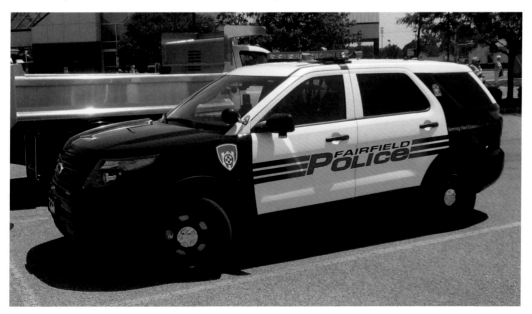

MARSH RESIDENCE, PLEASANT AVENUE: Cindy Marsh used to watch her dad leave their Nilles Road home and walk across this cornfield to get to work at the Municipal Building located on the right. She had no idea that one day her dad would become the Chief of Police and ultimately mayor during the 1970s. In the early 1980s, the city's first shopping mall with Kroger as the main tenant replaced the cornfield. The mall closed when Kroger moved to Village Green in 2002. The mall was torn down in 2003 and the city's Criminal Justice Center was built on the site.

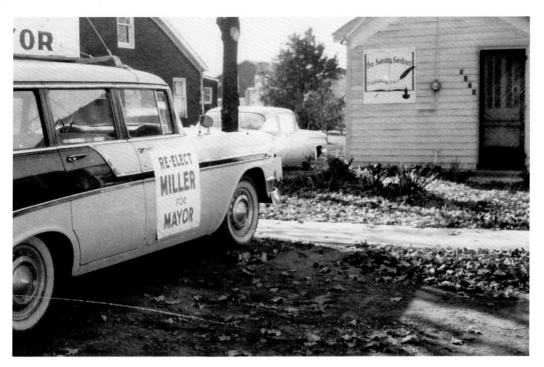

SUNDAY SENTINEL NEWSPAPER, SYMMES CORNER: The former Jessup home of the 1920s became home of the city's second weekly newspaper, the *Sunday Sentinel*, for a few years during the early 1960s. The *Sentinel* was financially supported by the owners of WMOH-AM but the newspaper failed to match the popularity of Fairfield's first weekly, the *Fairfield Echo*. The building was located next door to Larry Schleman's Fairfield Pharmacy and was torn down in 1967 to make way for a medical building.

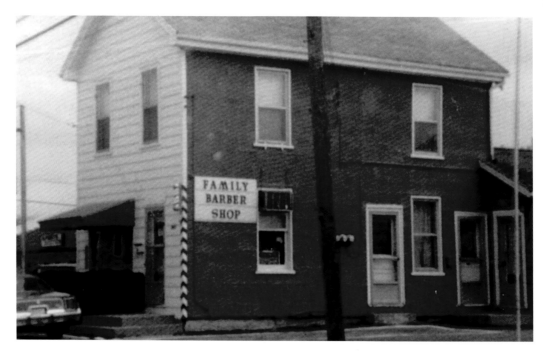

REDMON'S BARBER SHOP, PLEASANT AVENUE: Fairfield has never suffered from a shortage of traditional barber shops. Redmon's stood out among its competitors because of the red building it was located in. Redmon's was one of many barbers, including Eddie Fletcher, Rick Broshear, Phil Long, Clarence Strunk, Elvin Strunk, Mike Bundy, and Angelo Biondo among others. In 2015, the city has its share of family hair salons but the traditional barber shops such as Hicks Manor, Sandy Lane, Nilles, Fairfield, Tony Biondo & Son, and the Dixie Chicks still exist. The latter three shops are within 500 feet of the former Redmon's building which now is a parking lot for Riegert Square shopping center.

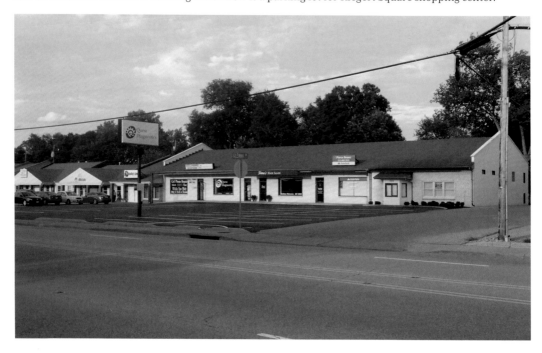

SYMMES MISSION CHAPEL, SYMMES CORNER: Constructed in the 1840s by the congregation that included Benjamin Symmes (who donated the land), Abram Huston and John Mesler. By the 1850s members had moved to Hamilton County and the building was abandoned. It remained in use by community groups, including the Symmes Community Chapel, until 1968. This Easter Sunday class in 1953 had twenty-three children and two teachers (back row on left). In 1980 the site was chosen to be on the National Register of Historic Places based on its common country church design, free of any ornamental design. Due to safety concerns and the inability to renovate the building, it was torn down in the 1990s and the lot remains vacant today.

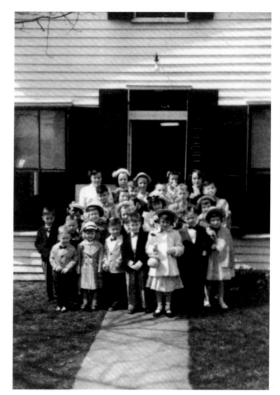

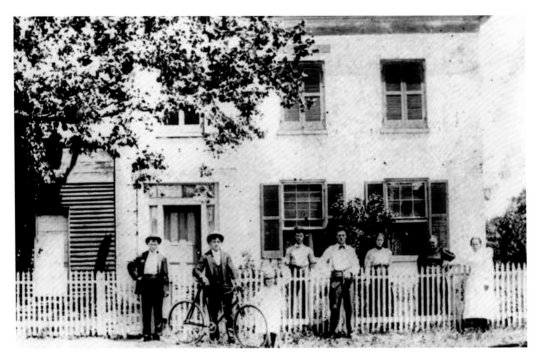

SYMMES TAVERN, SYMMES CORNER: The building was constructed in 1852 by Benjamin Randolph Symmes, the son of Celadon Symmes. Celadon and Joseph R. Symmes, whose home burned down on the same site operated the tavern and lived upstairs. In 1891 the building was sold to William and Louis Huth (pictured above in 1898) and the tavern was closed. The home was sold to Charles and Clair Nilles, the namesake of Nilles Road, in 1904. In 1940 it was sold to Otto and Louis Kuehlthau who reopened the tavern in 1961. Their son Hans Otto Kuehlthau operated the tavern until 1980.

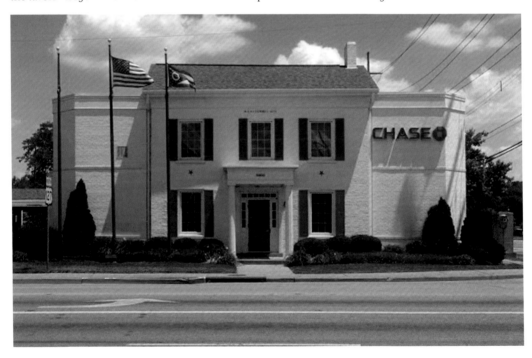

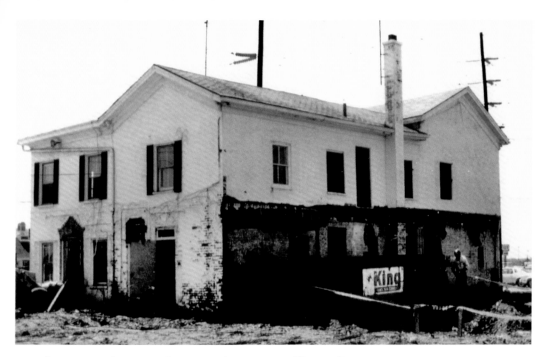

SAVINGS OF AMERICA, PLEASANT AVENUE AND NILLES ROAD: In 1985 the building was sold to Shell Oil who planned to construct a gas station. A group of local activists led by Dianne Robinson and Howard Dirksen convinced Shell to salvage the building. In early 1986, Savings of America (now Chase Bank) took over a lease agreement which required the building to be preserved. Two additions were constructed on each side of the building, but the original façade of the building was preserved. The memories of the original Symmes Tavern lives on at Symmes on the Green located in Village Green and features many old photos of the tavern.

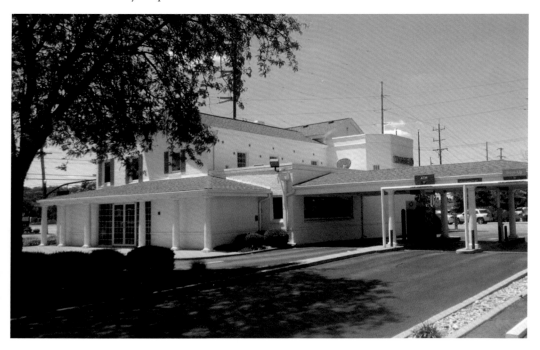

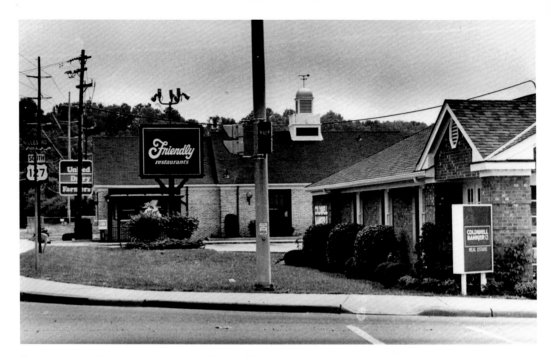

SOUTHBOUND PLEASANT AVENUE AT NILLES ROAD: The heart of the city lies at Pleasant Avenue and Nilles Road. Many businesses have come and gone, despite the popularity of the four corners and the expansion of Pleasant Avenue in 1973 and 1988. In the early 1970s Friendly's Ice Cream constructed a building literally a sidewalk away from the street and directly next door to one of its competitors, United Dairy Farmer. The restaurant was always busy but ultimately the company began to unravel and the Pleasant Avenue location closed. The owner of the building that housed UDF purchased the Friendly's location and replaced the UDF building with a larger structure and allowed UDF to sell gasoline.

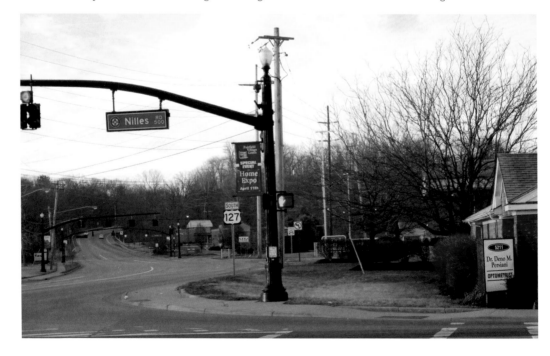

LANE PUBLIC LIBRARY, WESSEL DRIVE: A proposal in 1964 called for an exclusive building to be built on city owned land and to be managed by the Lane Public Library system. The proposal was accepted and the Fairfield branch became Butler County's first structure since 1866 to exclusively house a library. Groundbreaking was held in 1966 with Mayor Noah Creech (left) and prominent Hamilton businessman Robert Brown standing in the middle of a cornfield at the abrupt end of Wessel Drive. In 1979, the building was expanded but within a few years, space became an issue once again. In 2001 the library moved to Village Green and the city took over the old building to use as an annex.

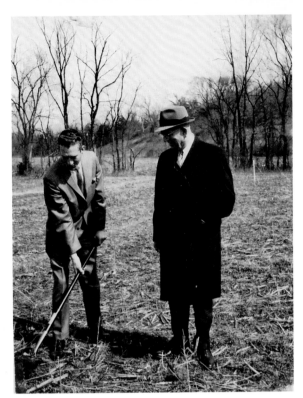

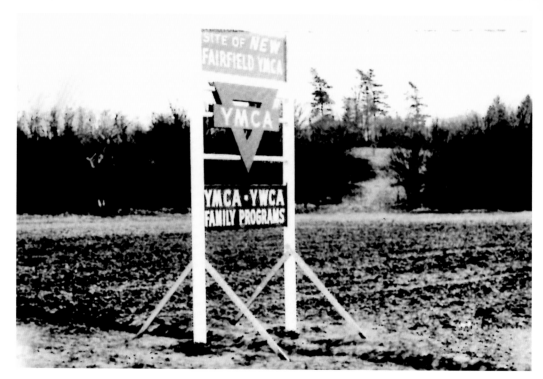

YMCA, BILBURY ROAD AND NILLES ROAD: Groundbreaking was held in 1970 for the 90,000 square foot Fairfield branch on land purchased from John Griesmer. The branch included an indoor swimming pool, locker rooms, classrooms and traditional exercise equipment. In 2004 over $2 million dollars was invested to add 4,000 square feet. In 2015 the Fairfield Family YMCA offers cardio and resistance equipment, strength training, group exercise studios, a cycling studio, an indoor walking/running track, gym, lap pool, warm water pool with slides, an outdoor playground, a day care center, whirlpool and sauna.

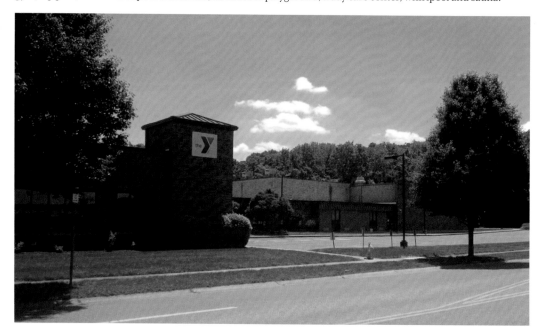

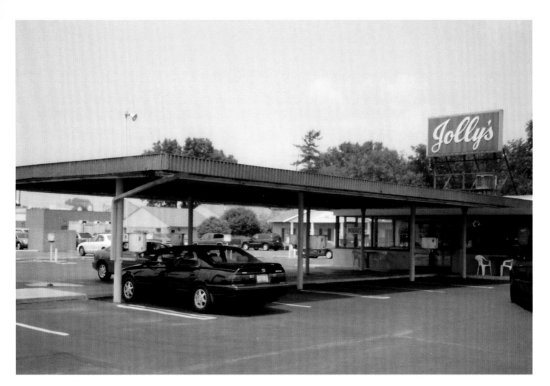

JOLLY'S ROOT BEER STAND, NILLES ROAD: The Jolivette family already ran two successful root beer stands in Hamilton before opening up a stand in Fairfield in the early 1970s. The stand replaced two pre-World War II homes but quickly became the summer meeting place for old and young alike. As Village Green began to develop nearby, the value of the land enabled the family to sell the land in 2007 to Taco Bell. Jolly's continues to operate in Hamilton.

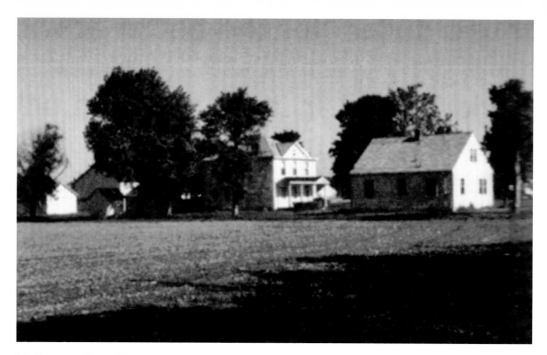

MCCORMICK FARM, VILLAGE GREEN: The McCormick Farm (also known as the Beatty Farm) was the last farm in Symmes Corner that withstood commercial expansion. Originally over 150 acres in size, the farm encompassed most of what is today Village Green and portions of Southgate Boulevard. The first recorded sale of the property occurred in 1796 to Cornelius Hurley at a cost of thirty-three cents per acre. During the 1800s the property size and owners changed many times. In 1853 the first house was built on the property facing Pleasant Avenue and owned by the Pottenger family however they never lived on the property. William McCormick rented the house and farm in 1922 and purchased the property in the mid-1940s.

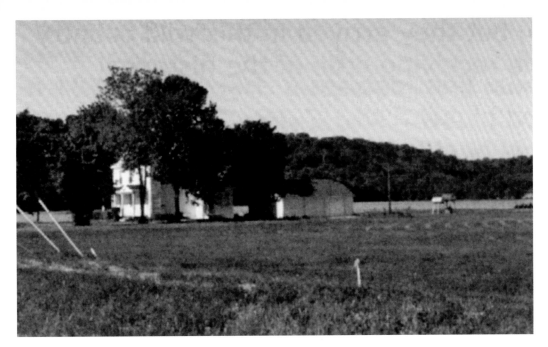

MCCORMICK FARM, VILLAGE GREEN: In the late 1960s McCormick sold ten acres for a building that housed Fairfield Hardware and United Dairy Farmers. In the mid-1990s the farm was sold to developer Joseph Schwartz to establish a mixed-use development to serve as a "downtown", called Village Green. Custom homes were built adjacent the development. The farmhouse was torn down and a Kroger store, a shopping center and a library opened in September 2001. By 2002 a 120-unit independent senior living complex opened along with Fifth Third Bank, the Women's Health Associates of Butler County, Eye Care Associates of Greater CVG, Huff Realty and CHACO Credit Union. The final piece of Village Green was completed in 2005 when the Community Arts Center opened.

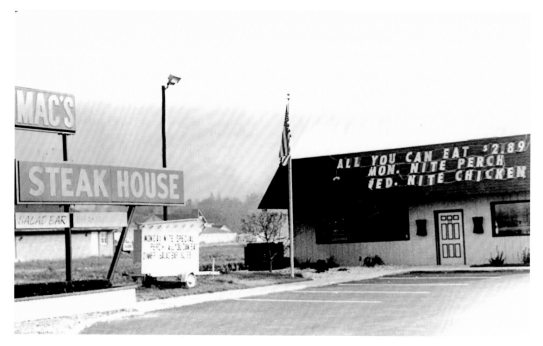

MAC'S HAMBURGERS, NILLES ROAD: The family-owned hamburger chain was based out of Indiana but found Fairfield and Oxford as an excellent venue to sell its menu of traditional hamburgers, French fries and shakes. When McDonald's opened its first Fairfield location just a few doors down from Mac's, the restaurant remodeled in 1977 and reopened as Mac's Steakhouse in an attempt to target a different audience. The effort failed to win over enough customers and Mac's finally closed. Pusch's Family Restaurant did a thriving business for years until it closed in 2005. The building was purchased by the Hamilton Italian restaurant chain Richard's in 2006 and continues as a restaurant nearly a decade later.

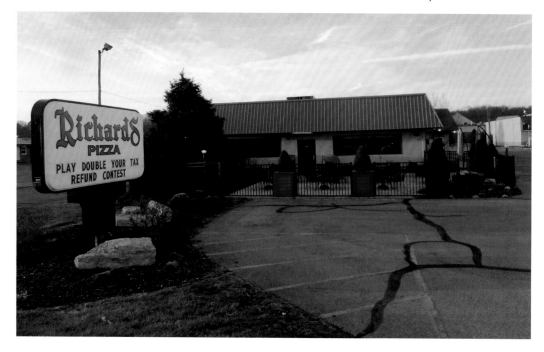

CHAPTER TWO

WEST – GREAT MIAMI RIVER

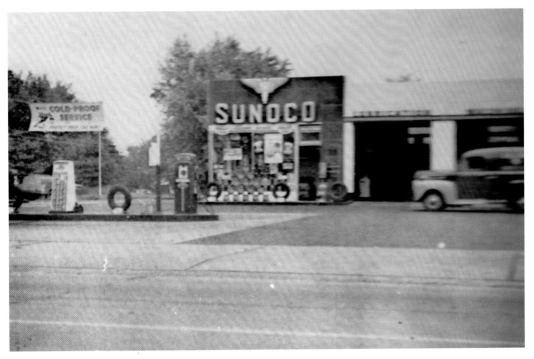

ED FOX SUNOCO, PLEASANT AND SYMMES: The Ed Fox Sunoco service station was a long-time fixture serving the area. Owner Ed Fox opened the station after World War II and operated it until the early 1970s when he sold it. The station continued operating until 2002 when a Walgreens replaced it. Fox moved on to operate Ed Fox Motors and Towing on Dixie Highway near the Fairfield Bowling Lanes. He retired in 1975 and served as the administrative assistant to Fairfield Mayor Clarence Phalen, a former automobile dealer.

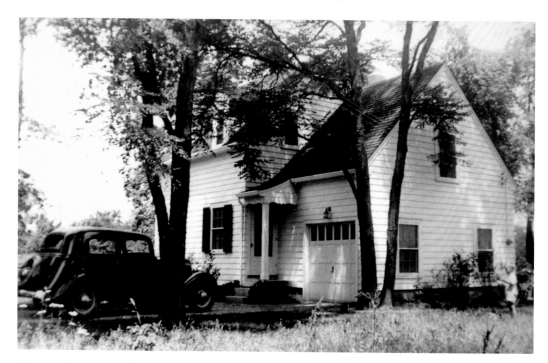

MILDER RESIDENCE, SANDY LANE: When the Milder's were not operating the restaurant, they spent time at their home entertaining celebrities. The Milder home was a favorite hangout for many members of the Cincinnati Reds baseball team, many who became close friends of the Milder's. In October 1938, Reds first baseman Frank McCormick married Vera Preedy at the home. Reds players often found comfort in this home where team members often slept on the cool porch to escape the heat of the Cincinnati hotels.

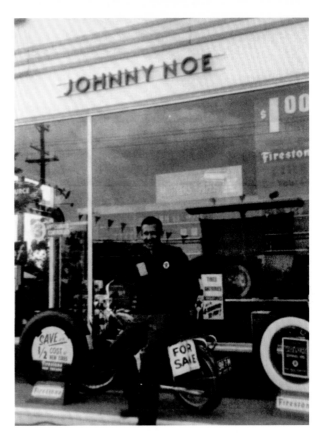

JOHNNY NOE'S TEXACO STATION, PLEASANT AND MAGIE: Johnny Noe was the first Texaco dealer to sell gas in the new city. The station stood alone at the busy intersection and may have contributed to the ultimate closing in the early 1970s. Butler Water Systems and owner Arthur Friedrich saw the opportunity to expand his Symmes Corner business and moved into old station in 1974. Business remains brisk in 2015 as he sells water treatment services for drinking water, water softening and disinfection systems.

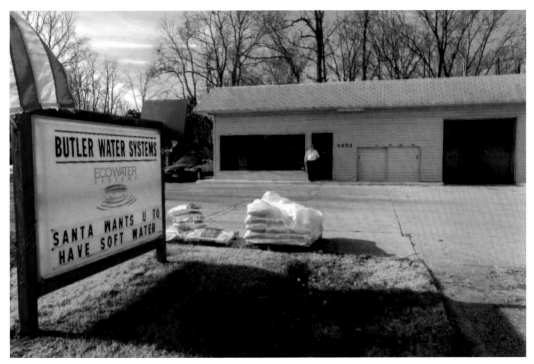

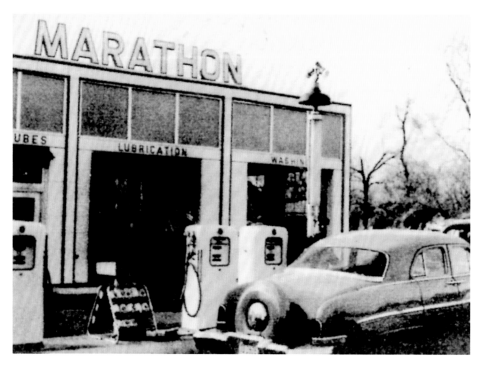

WEBER'S MARATHON, PLEASANT AND SYMMES: Weber's was one of the few Marathon branded stations in the area. The station shared a property line with one of the more popular independent grocery stores, Conrad's. During the late 1960s the station became Wayne's Humble Oil (and later Exxon due to company name change). In 1984 the station was torn down and a Super America gas and convenient store was built. Speedway ultimately purchased Super America and changed the name of the station.

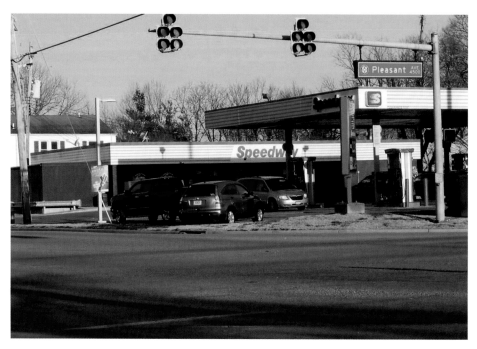

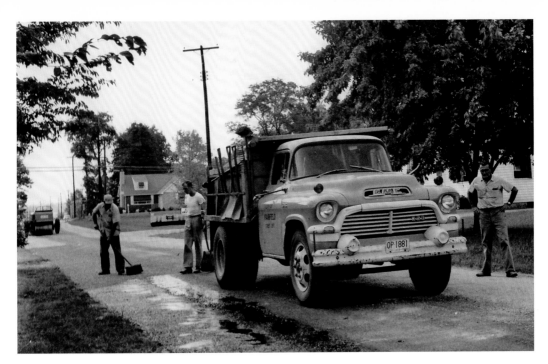

FAIRFIELD STREET DEPARTMENT: Now known as the Public Works Department, the city streets have been maintained by dedicated crews who work with hot asphalt in the summer and plow snow in the winter. Al Hayden (right) served as the city's first street superintendent that started out with one dump truck. In 2015, the department is responsible for twenty square miles and 376 lane miles of streets. From left to right is Charlie McHugh (in truck), Steve Taylor (with shovel), City Inspector Bill Heatherton, City Engineer Ben Mann and Equipment Operator Clint Emmons.

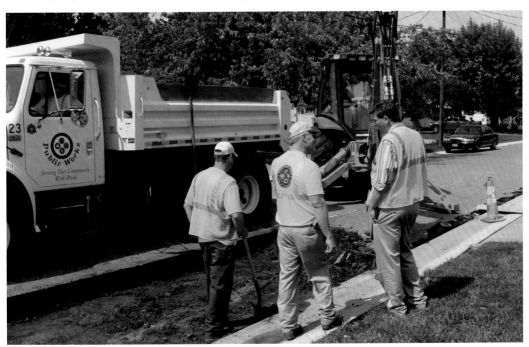

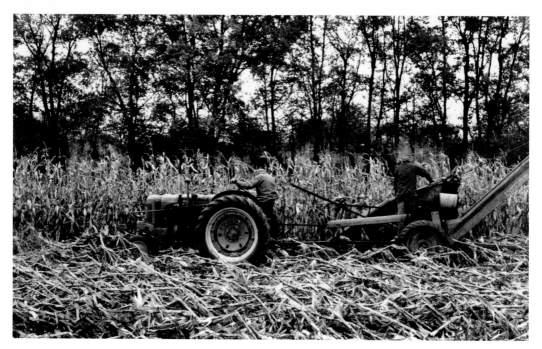

GROH FARM, GROH LANE: Pete Groh retired from his county job as an engineer to take over working one of the last farms in the city. He has owned his 1811 farmhouse for years and the acreage has decreased slightly from the original 111 acres his great-grandmother Mary Groh purchased in 1911. The 1940 tractor that his father used allowed Pete to help thrash corn and ready it to send out for shelling. In 2015, Pete and his cousin Blayne Groh use a combine that automatically shells corn and pushes into a container pulled by a John Deere tractor ready for shipping. In 2014, Pete was recognized by the State of Ohio and the city for owning a Century Farm.

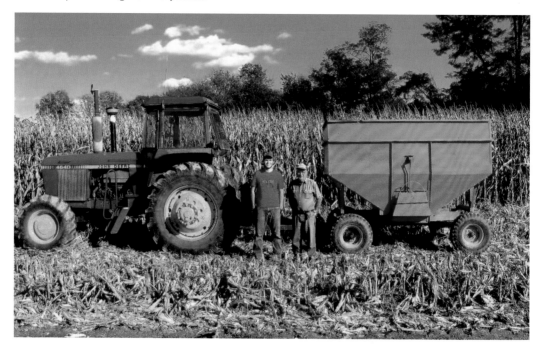

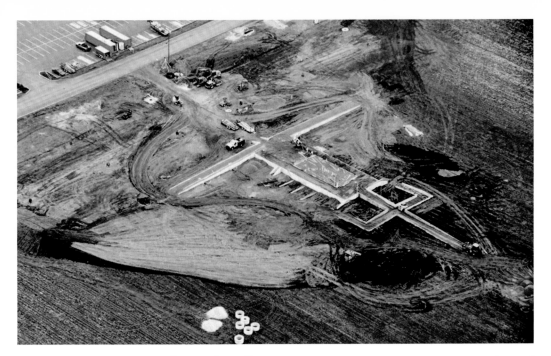

JOE NUXHALL MIRACLE FIELDS, GROH LANE: Fairfield's "field of dreams" opened in 2012 and named after Joe Nuxhall, the youngest player to debut in Major League Baseball in 1944. The "ole' left hander" was a very popular pitcher until 1967 when he retired and became a radio broadcaster for the Reds from 1967-2007. Kim Nuxhall, Joe's son, speared the development of the Miracle Fields after his father's death in 2007 to enable physically and mentally challenged children and adults to play baseball in a fun and safe environment and is the region's first multi-field complex designed for tournament play. Nuxhall was a passionate supporter of youth activities, especially the Hamilton-Fairfield youth baseball and softball leagues.

SACRED HEART CHURCH, NILLES AND RIVER ROAD: Sacred Heart Church and School was founded in 1957 by Archbishop Karl J. Alter, with Father Hugo Mentink as first pastor, and dedicated in 1960. Six additional classrooms were built in 1963 and a small gym in 1980. The present church was completed in 1989. Sisters of St. Francis, Oldenburg, Indiana, staffed the day-school and taught CCD classes for many years. A long litany of laymen and women have served the day-school, religious education programs, and other parish ministries and organizations. In 2015, the parish has nearly 2,100 Catholic households with a congregation in excess of 7,000 members. Day-school has grades one through eight, with over 400 students enrolled annually.

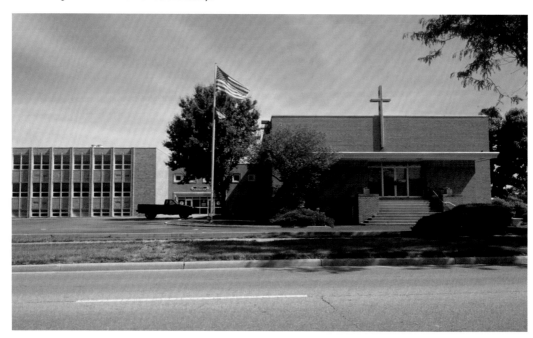

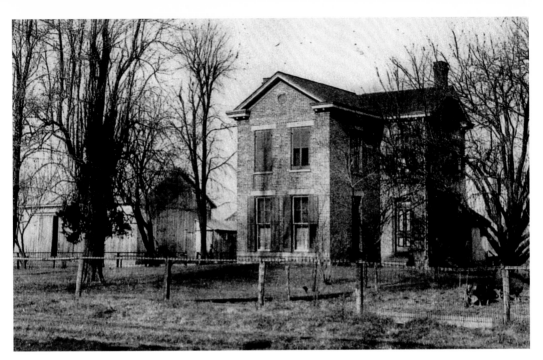

RUE FARM, RIVER ROAD: This stately home was the former home of Civil War Major George W. Rue. He was responsible for capturing Confederate General John Hunt Morgan who attempted to invade southwest Ohio. The earliest record of Rue residing in Fairfield was in 1868 but other records indicate that he could have made the home his primary residence as early as 1856. County records show that he purchased the farm in 1871 and worked as a farmer. Rue died in 1911 after living in Hamilton. The home and barn serve as a private residence although the farm was sold in the early 1970s for residential development.

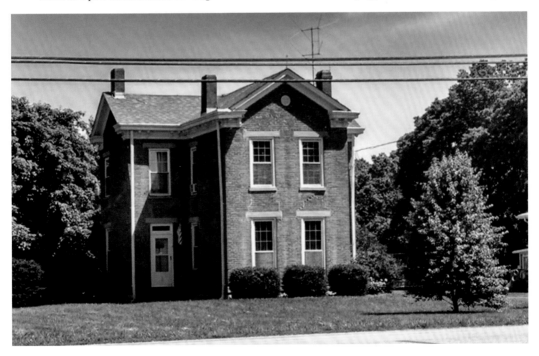

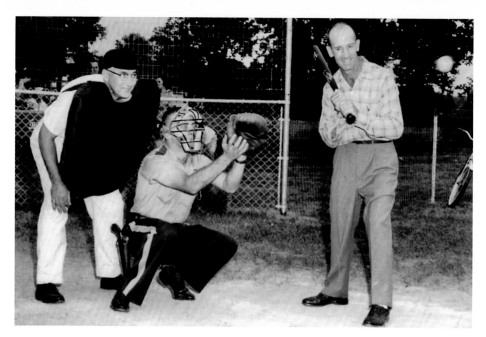

FAIRFIELD LITTLE LEAGUE/BABE RUTH LEAGUE, GROH LANE: In 1957 ball fields were installed behind the Fairfield Waterworks building and unleashed a tradition that continues over fifty years later. As a sign of unity, Fairfield School Superintendent Robert Cropenbaker dons an umpire uniform while Little League President Leonard Abney bats while an unidentified Fairfield Police officer handles the catching duties. Cincinnati Reds pitcher and resident Joe Nuxhall was an avid supporter for the program and spent time raising funds to provide opportunities for area children to experience baseball. In 2015, the Fairfield Youth Baseball Association manages baseball and softball activities. The fields are maintained by Ken Willsey and the lighting that reaches ninety feet high is maintained by Nelson Hambrick.

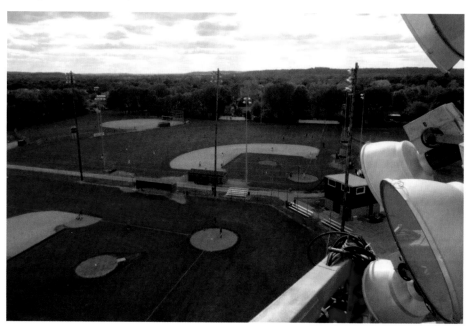

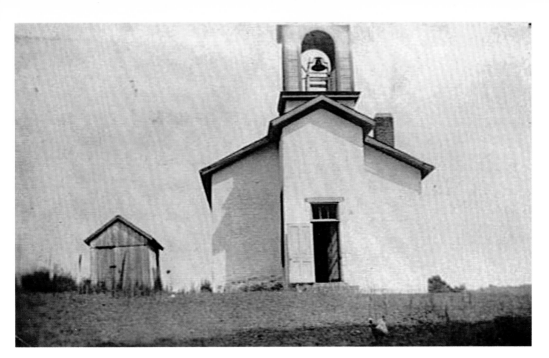

FAIRPLAY SCHOOL, RIVER ROAD: Built *circa* 1870, the building was one of several schools that closed after the Fairfield School District consolidated in one location in 1929 and served the area of Fairplay (Black Bottom). According to historian Esther Benzing, Joel Williams is believed to be Butler County's first real estate agent and built the first grist & sawmill in the county in 1798 near Burns and Georgetown Roads. Across the street was Hart's Block, perhaps the first subdivision in Fairfield Township at River Circle. Around 1866, a devastating flood destroyed the area and changed the course of the Great Miami River. The schoolhouse survived and was used as a corncrib before being converted into a residence.

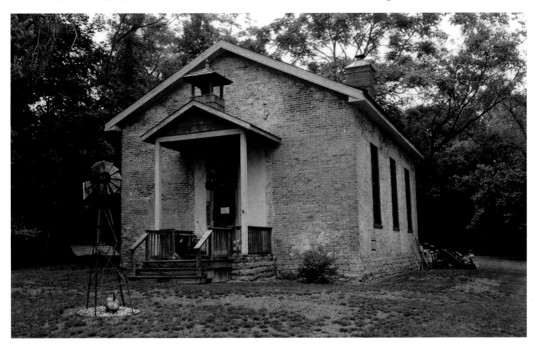

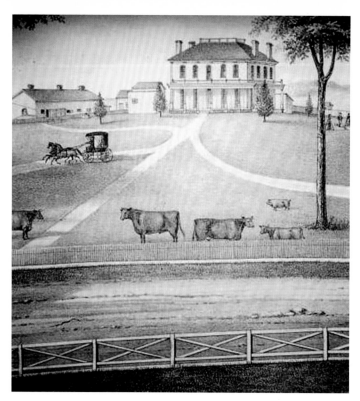

WILLIAM HUNTER FARM, PLEASANT AVENUE: From 1865 to 1875, William Hunter lived in this stately home that is now surrounded by custom homes and its driveway became Calumet Way. The farm survived development surrounding it but was finally sold in 1986 and the land surrounding the home was subdivided. The architectural style of the home is one of the most unusual in Butler County with its front porch columns gracing the front of the house and semicircular steps within the porch leading to the front door.

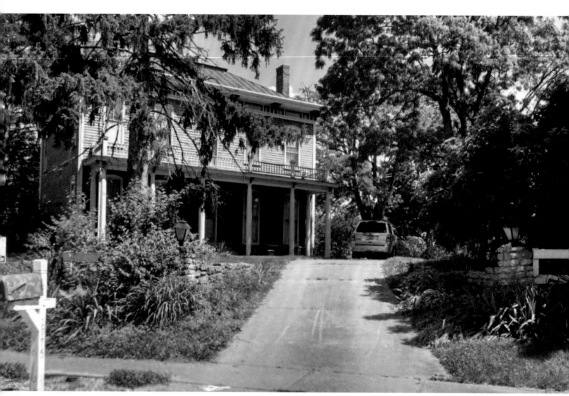

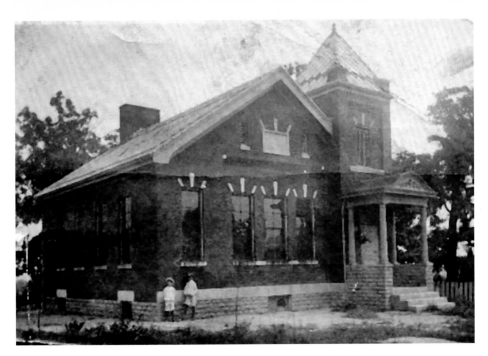

RESOR ROAD SCHOOL: Another building saved from destruction after the school district consolidated was this building. The 1909 red brick schoolhouse was the third known structure on the site. Gus and Betty Hanges, both former Fairfield school teachers, purchased the property in 1956 from the Hoelle family who had been using it as their summer home. The Hanges' restored the home as it had been expanded several times since 1869. The original school bell is displayed in the yard as a tribute to education. The name of the school has always been in question since documents record both "Reisor" and Riesor" as early landowners. It is not known when the current spelling was adopted.

McDonald Farm, Hunter Road: Fairfield's largest park was deeded in 1797 by Judge John Cleves Symmes to James Henry. Between 1802 and 1902, the property transferred fourteen times with the McDonald family farming it the longest. A nearby barn was built in 1880 by Ed Jessup as part of his adjacent property. The homestead was located where the picnic shelters are located today. No remnants of the existing house are present since the city totally re-contoured most of the area to accommodate parking and the scenic driveway. The park's namesake, William Harbin, served as mayor from 1972-1975 and spearheaded efforts to for its purchase in 1973.

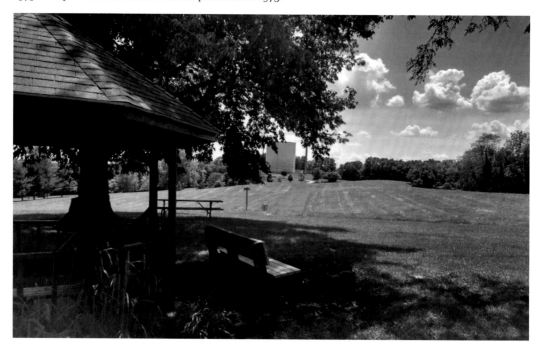

WEBER ESTATE, RESOR AND SIGMON WAY: Conrad Windisch lived on Port Union Road but owned rental property, including the Weber estate, named for H. M. Weber who farmed the land in the late 1800s. Windisch became a partner with Christian Moerlein in 1853 and the duo started a brewery in Cincinnati. Windisch used wheat from his farm as well as Weber's to use in his breweries. Windisch started his own brewery in 1862 and sold his interest to Moerlein in 1866. He then formed the Muhlhauser-Windisch & Company and the business became one of Cincinnati's leading brewers. The farm was developed into the site of Homerama 1972, 1973 and 1975; the last time it was held in the City of Fairfield.

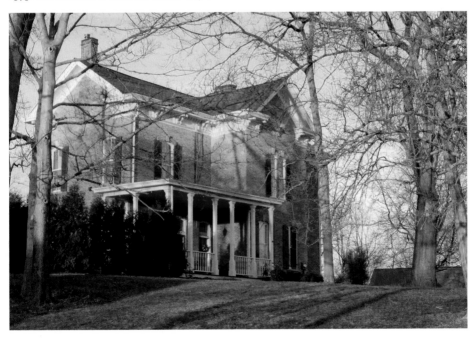

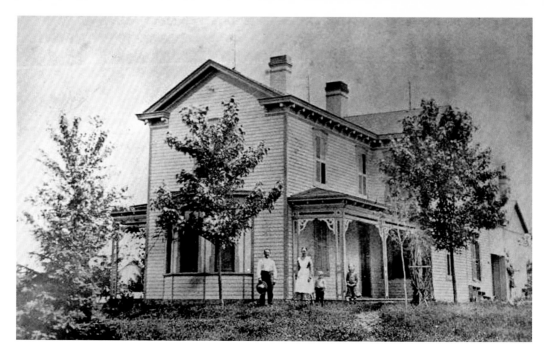

HUSTON FARM, PLEASANT AND JOHN GRAY ROAD: The Huston farm was one of two farms located near the Butler County and Hamilton County border. The original Huston home burned down in 1903, owned by David Huston (also recorded as Hueston), and this home was built in its place to almost the same style. Immediately adjacent to the Huston Farm was another Jessup Farm owned by F. G. Jessup that was established in the 1860s. In 1978 the farm was subdivided and the former home site was torn down to make way for a nursing home. Today, the building serves as an office facility for Pinnacle Management, a property management firm.

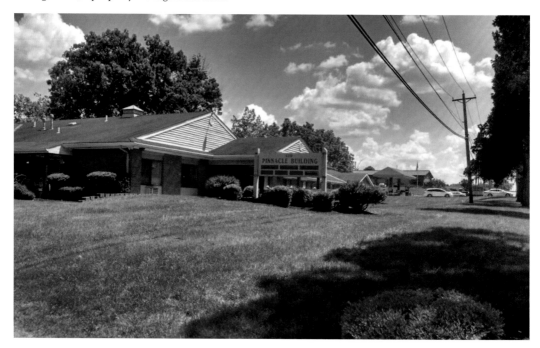

CHAPTER THREE

NORTHEAST – FURMANDALE

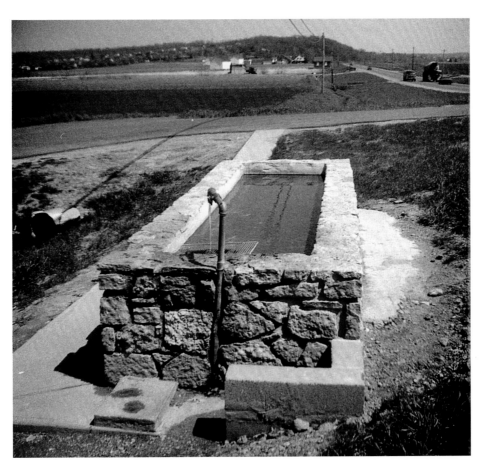

TYLERSVILLE ROAD WATER TROUGH: This spring-fed water trough on Tylersville Road was well known as a stopping point so animals could get a drink of water. In 1886, George H. Phillips repaired the trough on what was then known as Deerfield Pike for $3.05 to keep the concrete trough flowing. The 1875 Butler County Atlas listed W. H. Miller as owner of the property. Eventually, the county determined that the water was unsafe due to the nearby farms and commercialization of the area and closed down the trough. The basin remains as a roadside memory for many residents who came from miles around to get the best tasting water in the area.

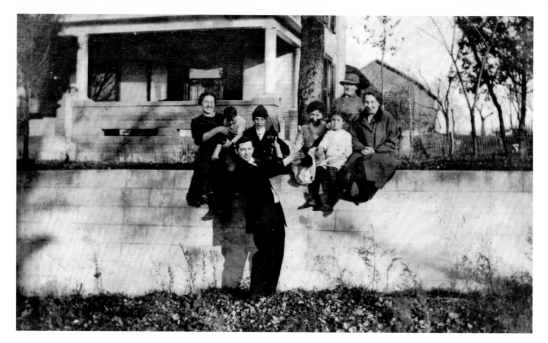

DINGFELDER FARM, WINTON ROAD: The Burer family have lived on this farm for over 100 years. The J. L. Dingfelder family established this home in the mid-1880s. In 1909 John Burer married Catherine Hoffman, the daughter of George and Laura Dingfelder Hoffman, and moved into the 205 acre farmstead. This early 1920s photo shows John Burer standing, Catherine Hoffman Burer (Tom's wife), sons Robert and George, Mamie Hoffman (Catherine's sister), Mary Kathryn Hayes (Tom's niece), Clara Hayes (Catherine's sister) and Laura Dingfelder Burer (John's wife). In 2015 the farm serves as the home of several Burer companies including, Universal Transportation Systems and Burer's Garage, who has held the Fairfield school district's bus maintenance contract for nearly seventy years.

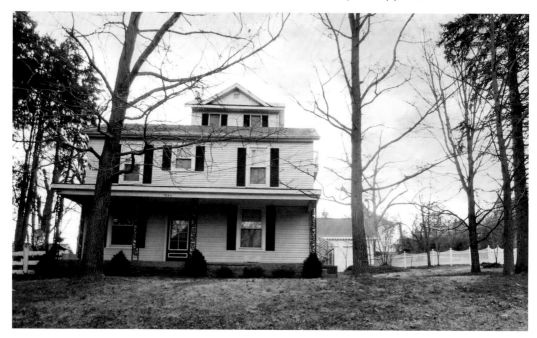

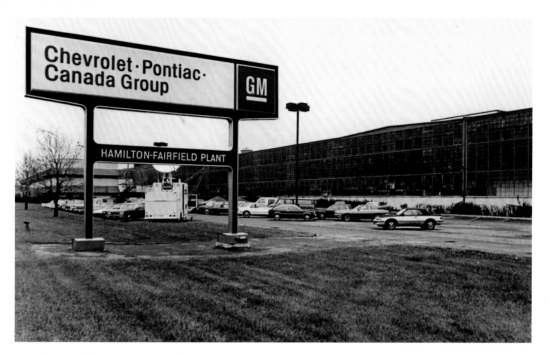

FISHER BODY, DIXIE AND SYMMES ROAD: General Motors opened the Fisher Body plant on 110 acres in 1947 to produce automobile parts and car panels for a variety of GM vehicles. The plant expanded in 1955 and 1961 and utilized over 1.5 million square feet. Employment rose to 4,500 in the early 1950s but fell to 2,500 in the 1980s as the car market changed drastically. In 1984 the name of the plant was changed to the Chevrolet-Pontiac-Canada Group. The plant closed in 1988 and the property sold to Panda Motors Corp. Plans to reopen the plant failed and the property was sold in 2005. In 2015, Fisher Park Industrial Center leases portions of the building to industrial and commercial users.

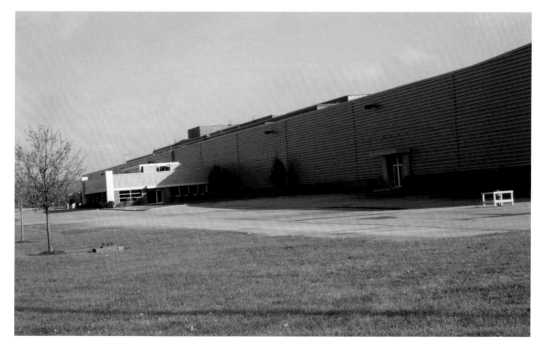

CHARLES WALKE RESIDENCE, DIXIE HIGHWAY: During the 1930s this was the residence of Charles Walke, the Butler County Sheriff from 1937 to the early 1950s. He passed away at the residence in 1969. This steeply-pitched projecting section of the center of the front façade of this home contains a round-arched door way and is one of the most distinctive homes in the area. It was then purchased by Herb Bales, a local jeweler who became internationally known after becoming the first person in the world to have diamonds implanted in his teeth in 1973. Bales sold the property and the adjoining property that housed his jewelry store in 2010 and five years later it is used by AMB Auto Sales.

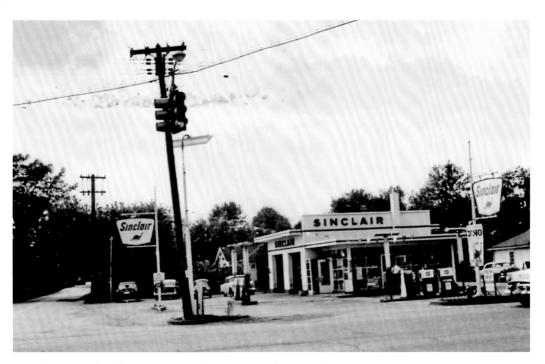

SINCLAIR GAS STATION, DIXIE HIGHWAY AND SYMMES ROAD: Sinclair gas stations were as common place as in the Midwest, but its decline in the 1960s forced the company to sell off many stations, including Ohio. After this station closed in the early 1960s, the Dixie Auto Top was established to repair and install convertible car tops. By the early 1970s the Hitching Post carry-out moved in but failed to compete with Kentucky Fried Chicken and Carter's located nearby. In 1976 the building became the home of a tropical plant company servicing professional offices. In 2015, the building serves as an office for Dixie Imports.

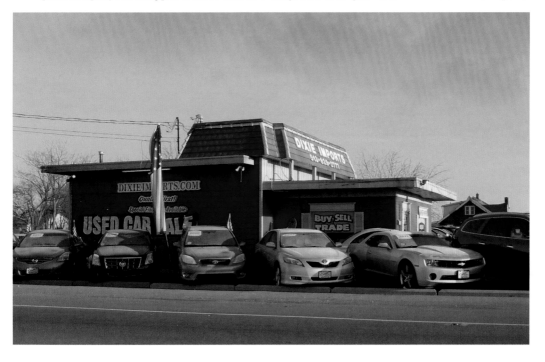

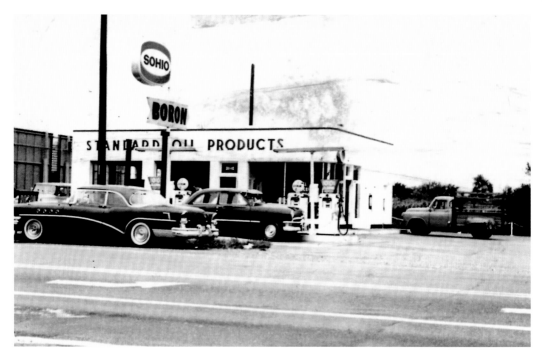

SOHIO GAS STATION, DIXIE HIGHWAY AND SYMMES ROAD: Sohio reigned as the leader in gas sales, especially since it was an Ohio-based company. This station was located directly across the street from Sinclair and later a Shell station on the opposite corner. It's location near the Fisher Body plant and Ohio's reputation in the region almost ensured its success. Once surrounded by a cornfield, the company decided to sell the station as other commercial development nearby increased the value of the business corner. First Financial Bank purchased the property in 1995 and tore down the station to build a branch location.

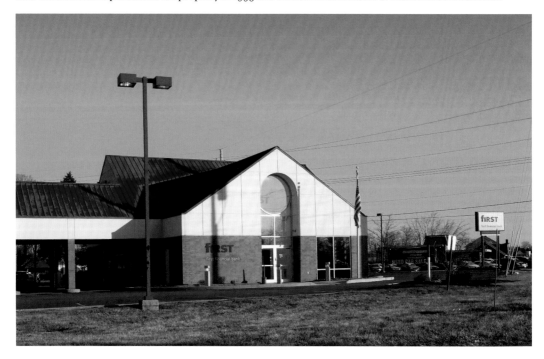

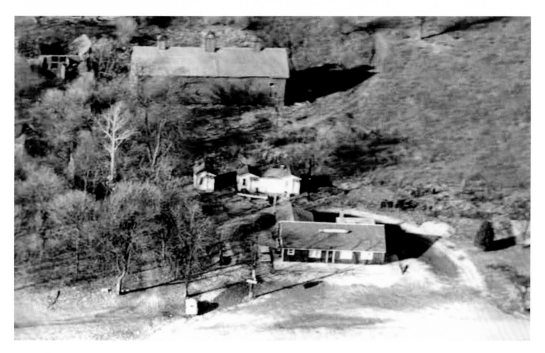

GREEN LANTERN, DIXIE HIGHWAY: In the 1800s, Matthew Hueston constructed one of the township's first buildings and opened a tavern. In 1813, Obediah Schenck bought it and remodeled it utilizing the original log structure. He sold it to John A. Slade in the 1920s. In 1927, Slade purchased WMBK/WRK, the first radio station established in Butler County, and built a transmitter and studio adjacent to the tavern. In 1930, Slade died and the tavern sold to Edith Freund and operated by Matt Walden. In April 1934 the tavern was closed by US Department of Justice after several weapons connected to John Dillinger were found on the property. The tavern reopened shortly thereafter and the owners cleared of any wrongdoing.

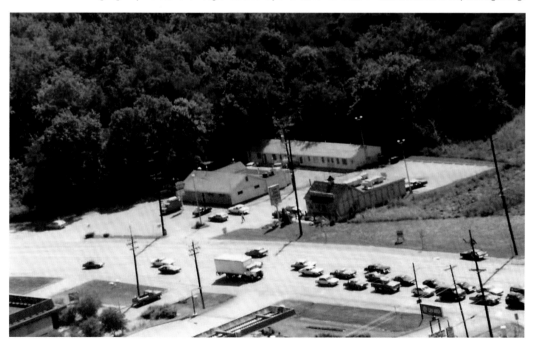

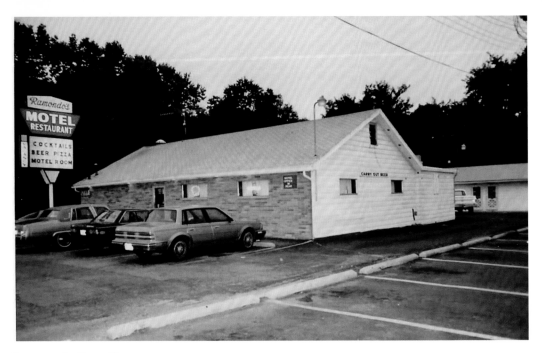

RAMANDO'S, DIXIE HIGHWAY: Ray and Edith Bacher and Tommy Withrow purchased the Green Lantern in the late 1940s. The Bacher's became sole owners by 1951 and renamed it in honor of Ray's father and his mother's Italian heritage. Ramondo's provided quality Italian dinners, a traditional bar, and rental units behind the building until 1989, when the Bacher's retired. No one was interested in carrying on the Ramondo's tradition so Bacher tore down the building and sold the land. In 2015, the site is the home of a storage barn facility. The land behind Ramondo's became the Fairfield Crossings Shopping Center in 1993. Edith Bacher, née Solazzo, has the distinction of being Fairfield's first homecoming queen in 1944.

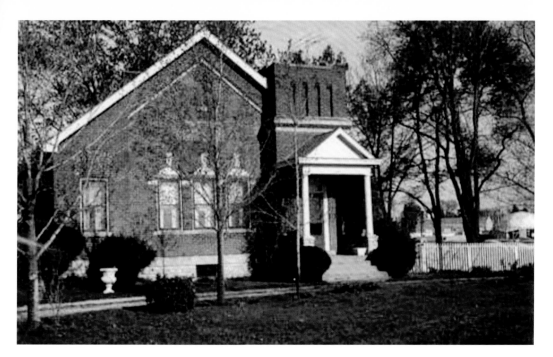

SLADE SCHOOL, DIXIE HIGHWAY: Fairfield Township School #6 was built in 1908 very similar to the Resor Road School. The school replaced the former Furmandale/Snaptown School that was constructed on the site in 1868. After the school district consolidated in 1929, the school became a private residence. Succumbing to increasing property values, the building was sold to the Wendy's restaurant chain in 1981 after an effort to move the building proved too expensive. Wendy's officials, sensitive to the emotional attachment that many residents had with the building, used the bricks and constructed a memorial to the schoolhouse in front of the restaurant.

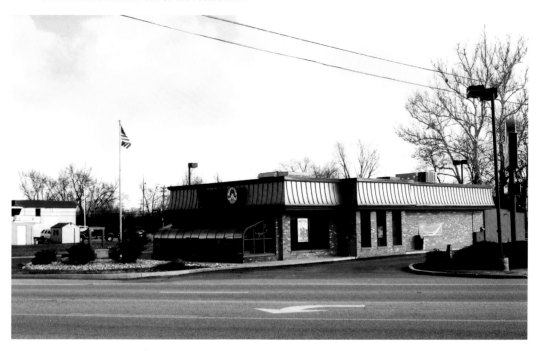

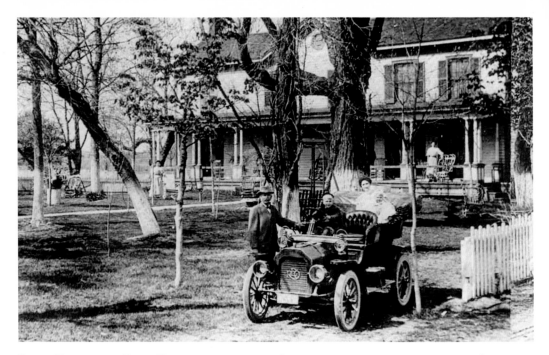

SLADE HOMESTEAD, DIXIE HIGHWAY: John C. Slade (shown behind the steering wheel in 1909) was one of three children raised in this home that featured electric lights, an air pressure water system and mail delivery several times a day. It was located adjacent to the Green Lantern and across the street from Slade School. Slade's father John A. (left) died in 1930. The home was destroyed by fire on February 23, 1935. A traditional two-story frame house was built on the same site several years later. The house was torn down in the early 1970s was replaced by a Sunoco gas station. In 1998 the gas station was replaced by Advance Auto Parts store.

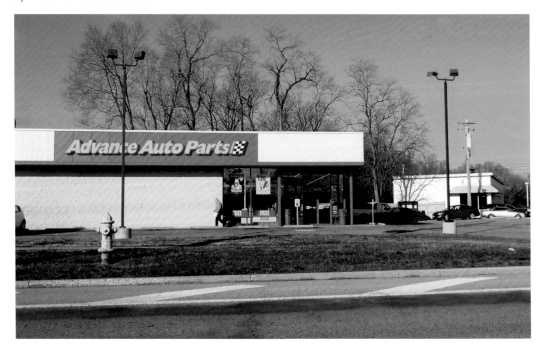

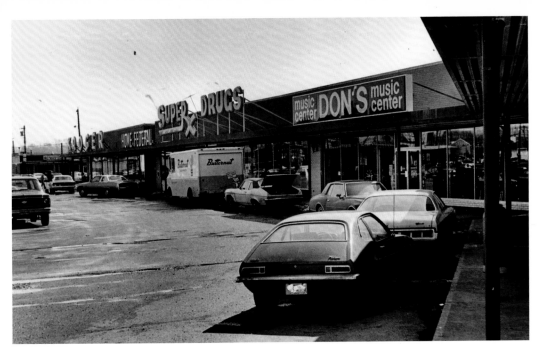

HICK'S MANOR SHOPPING CENTER/COBBLESTONE PLAZA, DIXIE HIGHWAY: The city's oldest shopping center opened April 1957 by John C. Hicks. The center's oldest tenant, Cassano's Pizza, continues to operate in the same location today. Hicks was responsible for developing the majority of homes in the area bounded by Symmes Road, Fairfield Avenue, Nilles Road and Winton Road. Hicks Boulevard was named for his effort in providing quality housing to the growing city. He also developed the Hicks Manor Industrial Park on the east side of Route 4. In 2008 the center was sold to Tom Burer, whose development company owns several properties in the city.

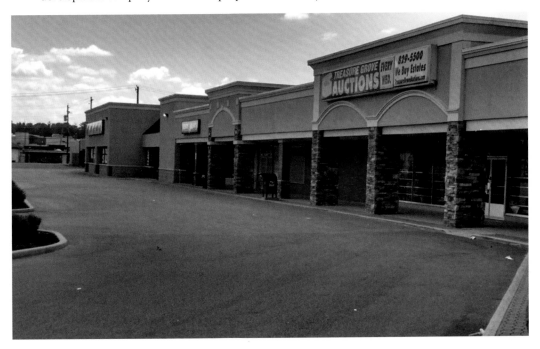

SHELL OIL, KILM CHEVROLET, DIXIE HIGHWAY: Across the street from Hicks Manor was a Shell Oil gas station (formerly a Sunoco) and Kilm Chevrolet Body Shop and Kilm OK Used Cars. Although Kilm Chevrolet was located in downtown Hamilton, it maintained its used car building on this site. The octagon building in the center of this photograph served as the main office. The body shop is to the left. Kilm Chevrolet went out of business in the mid-1980s and the used car lot sat vacant for several years until McDonald's opened in 1999. The former body shop facility was originally constructed in 1969 and was remodeled in 2002 for one of the branches of the Fresenius Dialysis Center.

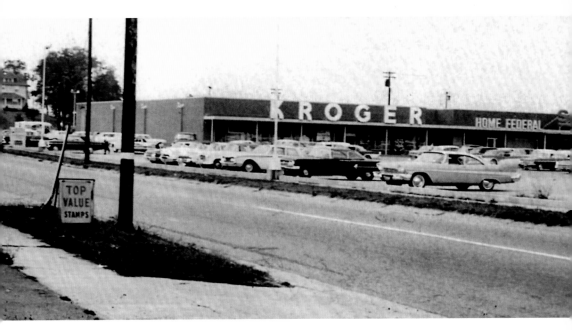

KROGER, DIXIE HIGHWAY AND MAGIE: The Kroger store was one of the first tenants of the Hicks Manor Shopping Center and remained there until the store moved to the Fairfield Mall, the city's first indoor shopping mall on Nilles Road in the early 1980s. The stately home that sits atop the hill at Magie and Holiday Drive has been overlooking the area since it was built in 1887. The strip center on the left was home for years to established companies such as Al-Joe's Garden Center, 12-30 Optical, Fairfield Cleaners and Highland Dairy. The center's original tenant, The Elbow Room, continues to operate today.

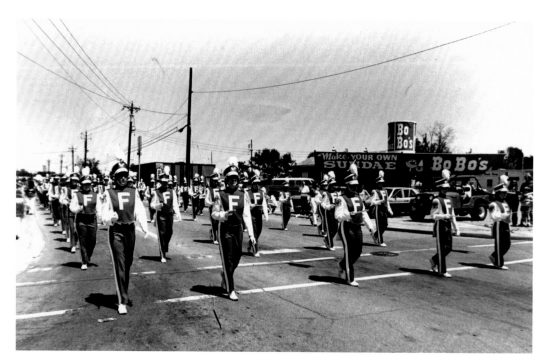

Bo Bo's Ice Cream, Dixie Highway and Hicks Boulevard: Bo Bo's replaced another summer icon, the Frost Top Root Beer stand, in the summer of 1973. Bo Bo's featured a make-your-sundae stand that enabled patrons to indulge on not only the ice cream but the toppings. Due to Bo Bo's location, the area behind the restaurant served as a staging area for various city parades, including one in which the Fairfield High School Marching Band participated. By 1987 the building was torn down and a Subway restaurant was opened.

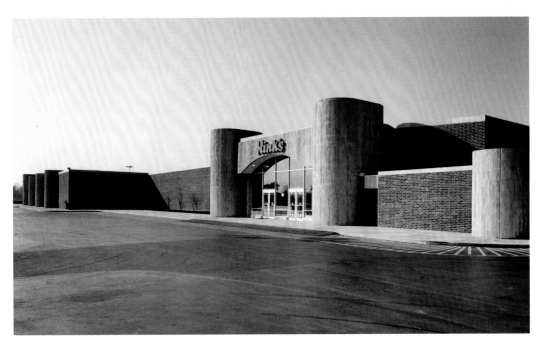

RINK'S BARGAIN CITY, DIXIE AND HICKS BOULEVARD: Hyman Ullner founded the retail chain in 1951 in a former roller rink in Hamilton. Rinks opened an annex on Dixie Highway in 1960 located in Fairfield. In 1972, Rink's moved to a single location in Fairfield to this facility. Rink's continued in operation until 1984 when the chain filed for bankruptcy. Rink's fans may remember Willie Thall and Ullner when they hosted "Shock Theatre" and Saturday afternoon wrestling on WCPO-TV. Ullner is remembered for declaring a set of plates "guaranteed breakable" and smashed them on the floor. The Rink's facility later became home of Central Hardware and is a branch of Medco Health Solutions, a medical prescription management company, in 2015.

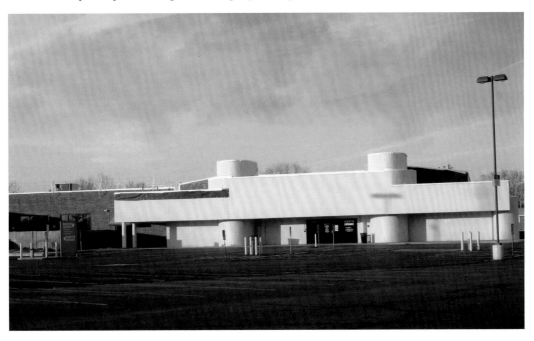

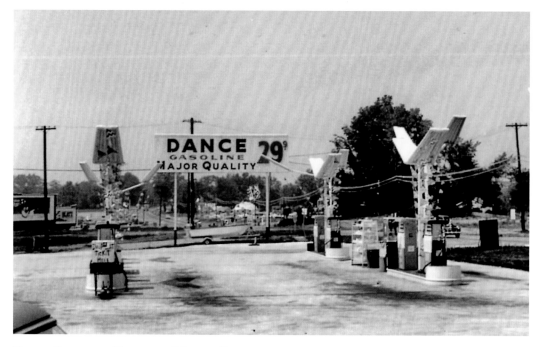

DANCE GASOLINE, DIXIE AND WINTON ROAD: Little is known about Dance Gasoline other than it was primarily located in the Midwest. This Dance station was the only one documented in Butler County when it was built in 1962 in what was once the heart of Furmandale. A tavern known as the Butler House was located adjacent to this site and was purchased by Nathaniel Furman who opened up the Furman's School for Ladies. The village was also known as Snaptown. Furmandale was awarded a post office in 1857 and had at least one store and a blacksmith. It was identified on some early maps as Snagtown and as Winton. The Gas Depot occupies the site.

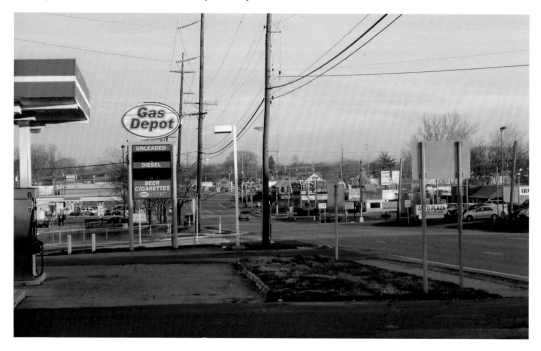

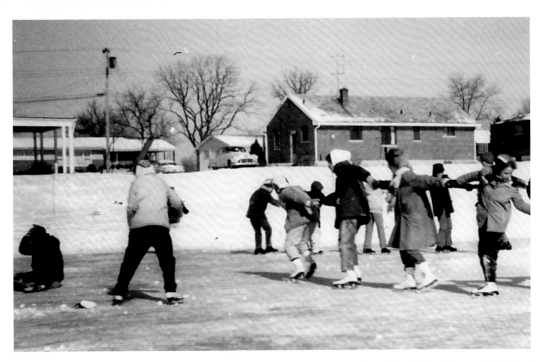

GOOD NEIGHBORS PARK, HICKS MANOR: When John Hicks developed the Hicks Manor subdivision in the early 1960s, he was able to design two green spaces he donated to the city for use as parks. Lions Park was developed off Hicks Boulevard and Good Neighbors Park was developed in a former gravel pit off Gail Avenue. The deep slopes surrounding the park and remnants of the old gravel bed underneath Good Neighbors provided an artificial lake in the winter for ice skating activities. Both parks remain a popular recreation area that feature a shelter, volleyball courts, a ball field and basketball courts.

CARILLON PLAZA, FAIRFIELD CONVENTION CENTER, DIXIE AND DONALD DRIVE: The Minnielli family concentrated their development efforts along Dixie Highway and the Hicks Manor Industrial Park. Carillon Plaza was conceived in 1969 and originally featured a CarpetTalk store and a paint store. Adjacent to the plaza, a Century Housewares fulfillment center was built in 1973, a concept similar to Best Products and Service Merchandise. By 1977 the company left town and the building was occupied by the Butler County Board of Mental Retardation, and Carpet by Ron and Solar America through the 1980s and 1990s. After sitting vacant for a couple years, the Minnielli family purchased the building in the late 1990s and opened the Fairfield Convention and Banquet Center at Tori's Station.

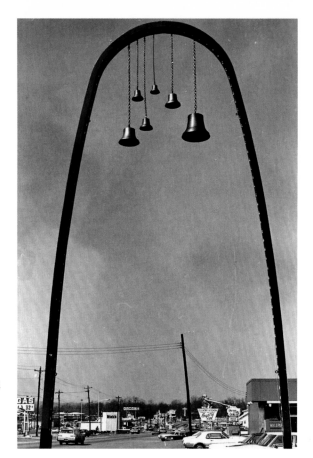

CARILLON BELLS, DIXIE HIGHWAY AND DONALD DRIVE: It quickly became an iconic landmark for Carillon Plaza and the city especially since Dixie Highway was becoming heavily concentrated with business after business. The carillon featured live iron bells and was built by Donald Napier and Lou Minnielli and designed by Bill Minnielli. The carillon was removed in the mid-1980s. The main bell decorates Donald's front yard in Brookville, Indiana, in 2015.

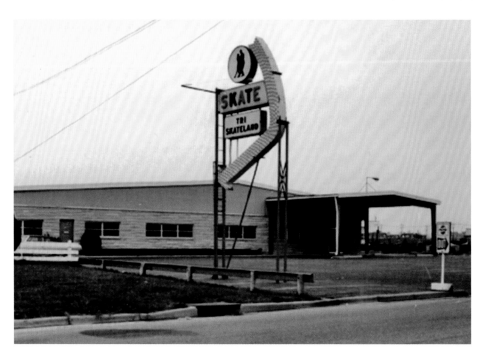

TRI-SKATELAND, HICKS BOULEVARD: Elmer and Kay Hammet opened the roller rink in 1965 after operating other rinks with family members. Tri-Skateland sponsored a speed skating team that enabled children of all ages the opportunity to display their talent and meet other skaters. In 1990 the Hammets decided to retire and sold the facility to their daughter, Joleen Harris, who continued operating it until 2015 under the name "The Rink." Alan Leonard, the owner of a chain of regional skating rinks, purchased Tri-Skateland in 2015 and changed the name to Skate America. New attractions include a bounce house, additional games and a ticket redemption center.

SOUTHERN OHIO COLLEGE, BACH LANE: Fairfield's first college began offering classes in the YMCA and in Hamilton but kept their north office in Fairfield. The Cincinnati-based for-profit school moved into its campus in August 1977, Bacher Square, located behind the Holiday Inn and Ponderosa Steak House. The campus enabled the college to consolidate its classes to one location. The school was later acquired Brown Mackie College, now a part of Educational Management Corporation. Fairfield City Schools purchased the building in 1995 to use as a dedicated kindergarten building. When the district decided to move their kindergarten classes to the elementary schools in 2011, the building became vacant until 2013, when the district moved their offices to the former campus.

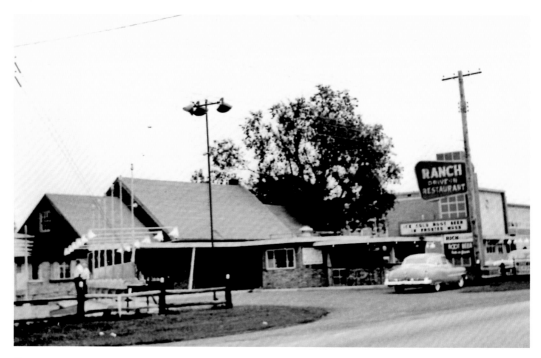

THE RANCH RESTAURANT, DIXIE HIGHWAY: Located next door was the Sunnyridge Food Shoppe and Trailer Park, the Ranch was a 1950s iconic drive-in since it was the favorite hangout after school and before football and basketball games held next door at the high school. In the early 1970s, the Ranch closed and the building became a branch for The Citizens Bank of Hamilton. During the bank mergers of the 1990s, the building was torn down in 1997 and a new building was built for a Society Bank where it continues to serve customers.

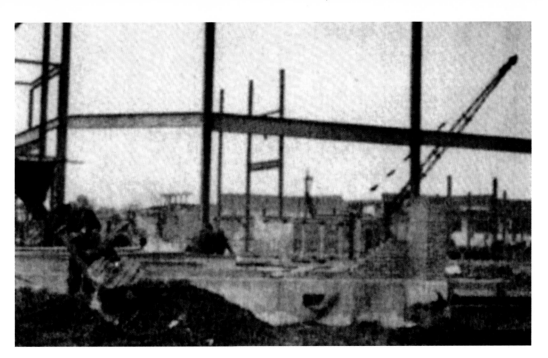

FAIRFIELD HIGH SCHOOL, DIXIE HIGHWAY: As the population grew, the need for an additional school became evident. This facility was built adjacent to Central and opened in 1951. Many schools built during this time utilized the Eliel Saarinen-inspired ribbon windows, prominent entrance areas and vertical shafts adjacent to the main entrance. A tunnel connected the high school to Central, enabling students to utilize the cafeteria. When the district opened a new high school on Nilles Road in 1961, this building became the junior high. By 1978 those grades moved to a new building and this building became a dedicated facility for freshman. It is scheduled to be demolished when a new building is constructed by 2017.

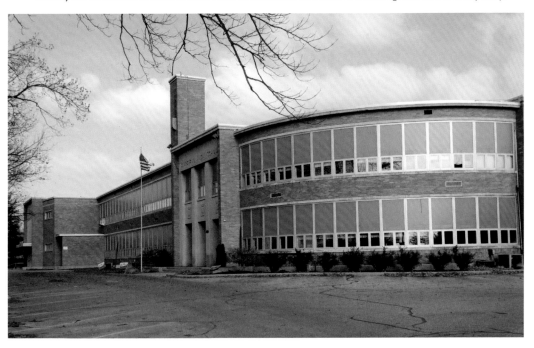

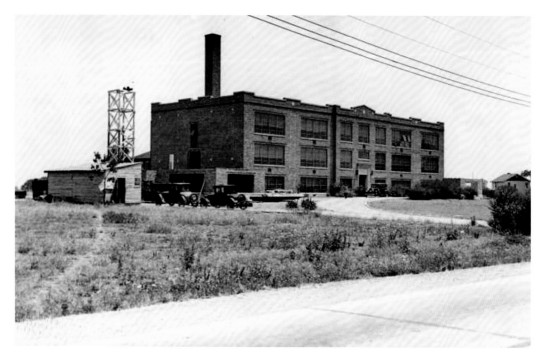

CENTRAL CONSOLIDATED SCHOOL, DIXIE HIGHWAY: The first centralized school in the township housed 416 students in twelve grades. The building was constructed for a mere $150,000 in 1929. Additions were made to the building in 1936 and an annex constructed in 1948. When a new high school was built in 1961, Central became an elementary school and continues in that role today. The building has remained virtually unaltered since 1929 and has become the subject of controversy when the district announced that the building would be torn down after a new elementary is constructed in 2017.

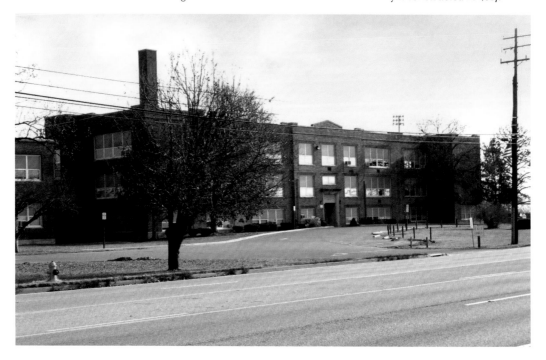

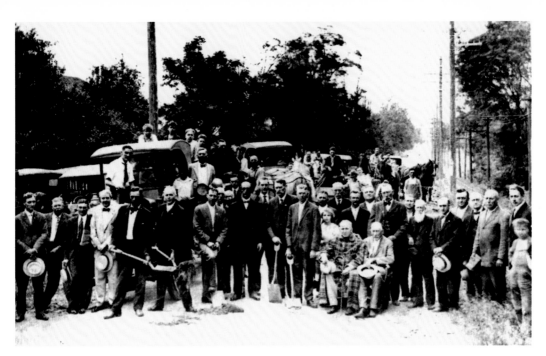

DIXIE HIGHWAY PAVING CELEBRATION: The community gathered on July 10, 1917 to celebrate the highway being designated a state route. The Butler County Good Roads Committee, led by Ben D. Lecklider, organized the ceremony to celebrate the transition from dirt and gravel to brick. About fifty residents attended the ceremony that took place near the intersection of Winton Road. Today, drivers curse the orange barrels and work crews who spend hours tearing out pavement and laying down a fresh layer of asphalt. The State of Ohio concluded that on average 35,000 drivers use Dixie on a daily basis. Also commonly referred to as State Route 4, the highway runs from Michigan's Upper Peninsula to southern Florida.

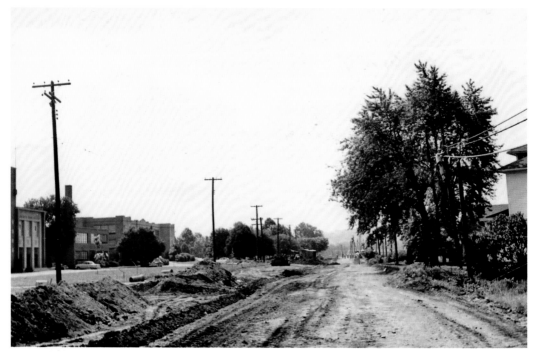

DIXIE HIGHWAY WIDENING: By the early 1960s, State Route 4/Dixie Highway was serving as a major transportation source, similar to how the old Miami-Erie Canal operated in the early 1800s. The State of Ohio expanded Dixie Highway in Butler County from two lanes to four lanes in 1962, including the 12.4 miles that ran through Fairfield. This section of highway is in front of Central School. The city works closely with the State of Ohio on maintaining the highway and keeping the highway up to date.

CHAPTER FOUR

SOUTHEAST – STOCKTON

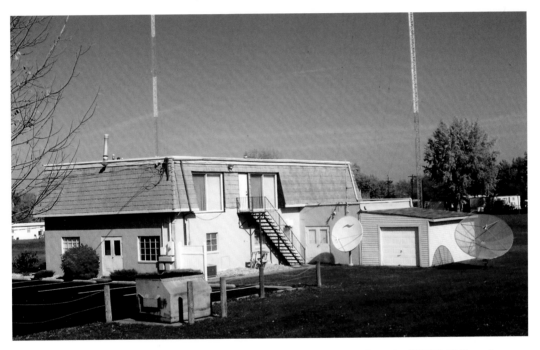

WCNW RADIO, MICHAEL LANE: Local contractor Walter Follmer launched WFOL-FM in 1962 and became the area's first full-time radio station to broadcast in stereo. In 1964, WFOL-AM made its debut playing country music. In 1965 the call letters of both stations were changed to WCNW. The popularity of WCNW-AM culminated in 1966 when the station held 51% of the country music listenership in the area. Follmer sold both stations to Broadcast Management Corporation of Cincinnati in 1975 and the call letters for WFOL-FM were changed to WLVV. In 1979, BMC sold the FM station to Heftel Broadcasting and sold WCNW to Vernon Baldwin in 1985. In 2015, WCNW-AM continues to broadcast Christian programming.

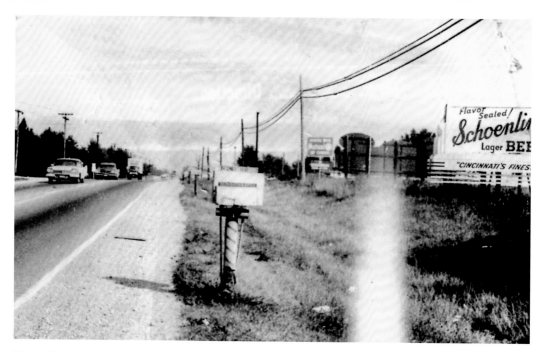

FROM OPEN FIELDS TO OPEN PARKING LOTS, DIXIE HIGHWAY: The site of Raleigh Guice Cadillac, the first minority owned General Motors dealership opened 1976 just to the right and next door to a golf center. Guice went out of business in the 1980s and Fairfield Ford moved into the space. In the early twenty-first century, Danco Transmissions opened up a branch and has begun selling vehicles from the site. Adjacent to the building is the Fairfield Pavilion Retirement Center and the Tri-County Extended Care facility. The entering and exiting of businesses through the years on the busiest highway in the area has not stopped the emergence of new businesses from establishing a home in this area.

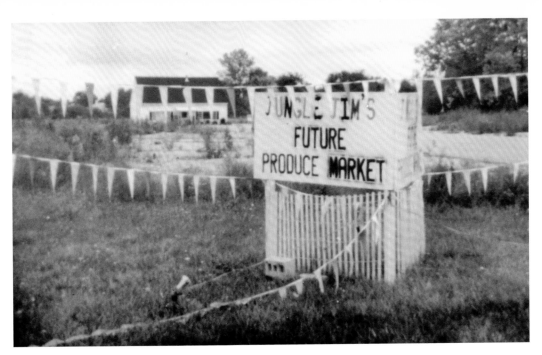

JUNGLE JIM'S INTERNATIONAL MARKET: Founded in 1971 in Hamilton by Jim Bonaminio as a small produce stand, the business moved to Fairfield in 1974. The store has expanded multiple times and now features over 180,000 items (about 60,000 which are international items) and over six and a half acres of floor space. Inside are several animatronics displays, such as a lion that sings Elvis Presley songs and a "rock band" composed of General Mills cereal mascots. With its latest expansion, Jungle Jim's has added a strip mall near the main entrance and rebuilt the old Lion Country Safari Monorail from the former Wild Animal Habitat at Kings Island. The Oscar Event Center, a 15,000 square foot space, opened in 2007.

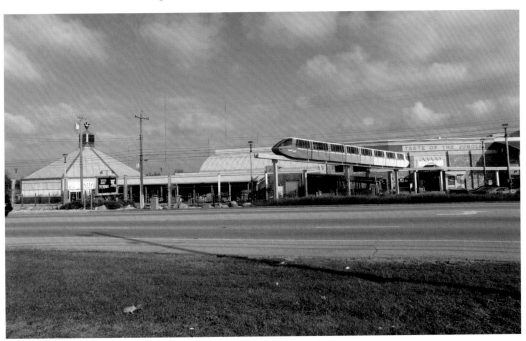

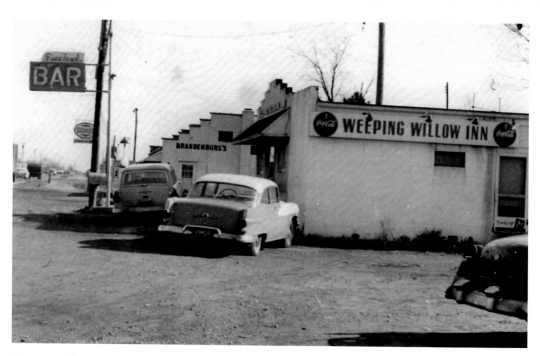

WEEPING WILLOW INN, DIXIE HIGHWAY: The popularity of Dixie Highway spawned many taverns with Weeping Willow being one of them. Helping the tavern's popularity was its neighbor, Brandenburg's Fairfield Market and Sohio Service Station. The tavern was sold to Emba and Pauline Williams in 1962. It is not known how long the tavern had been in business prior to this. The Williams' sold the tavern in 1966 and the liquor license was transferred to the Holiday Inn that was scheduled to open the following year. In the 2010s a car lot occupied the lot and a towing company operates out of the building constructed in 1941.

DIXIE AND GILMORE ROAD: One of the busiest intersections, and has been since 1994 when a realignment of Holden Boulevard, Port Union Road and Gilmore Road occurred. The intersection allows drivers to enter the city from I-75 and I-275. In the mid-1970s, a Denny's restaurant co-existed with Jungle Jim's located just up the road. It was torn down when the realignment occurred and a White Castle took its place in 2003. Today's congestion may have compared to the popularity of the intersection in the late 1920s when the Fairfield Dog Track was located here and held dog racing took in an estimated betting take of $8,500 nightly plus admission income; very big money in those days.

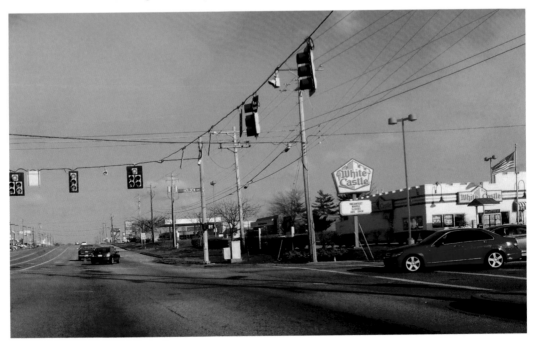

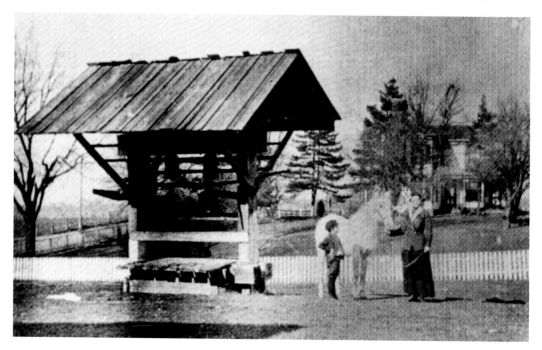

HALL FARM, FOREST FAIR VILLAGE, GILMORE ROAD: The John Hall family operated an apple orchard to manufacture butter until 1918 when the equipment was sold at auction. Hall used a cider press that could process wagonloads of apples in a few hours seen here with "Bill" the horse, Verna Hall and an unidentified child. Part of the farm was purchased in 1968 for I-275. The remainder of the land remained vacant until 1988 when the Forest Fair Mall was constructed and featured three upscale stores, thirty-seven specialty stores, a theatre and an amusement park, but attendance did not meet expectations. After a series of ownership and name changes, the latest name penned to the mall is the Forest Fair Village.

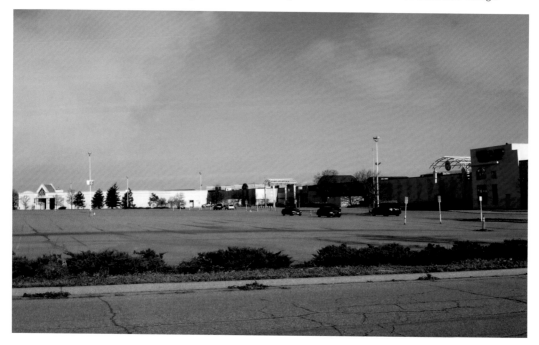

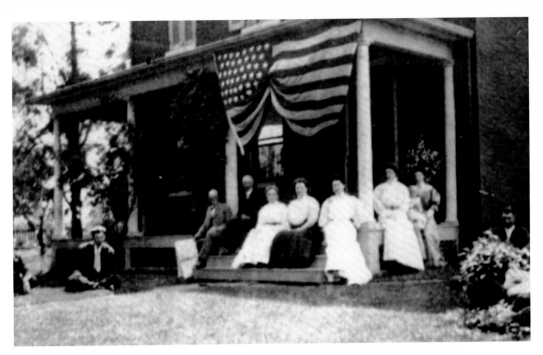

ELISHA MORGAN MANSION AT GILBERT PARK: Elisha Morgan purchased this forty-nine acre farm in 1817. Between 1828 and 1976, the farm was sold five different times until finally being vacated in 1976. In 1980, the city purchased the property to create Gilbert Park. The city planned to tear down the house, but residents convinced the city to save one of the few historic buildings left in Fairfield. Their efforts lead to the house being listed on the National Register in 1990. The house was restored in 1999 and is cared for by the Friends of the Elisha Morgan House. The family of Howard Ross is shown here on the porch during a Fourth of July celebration in the mid-1800s.

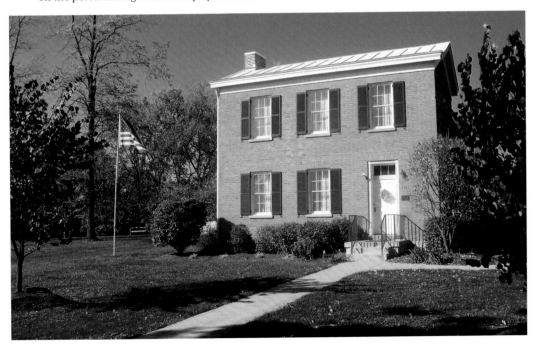

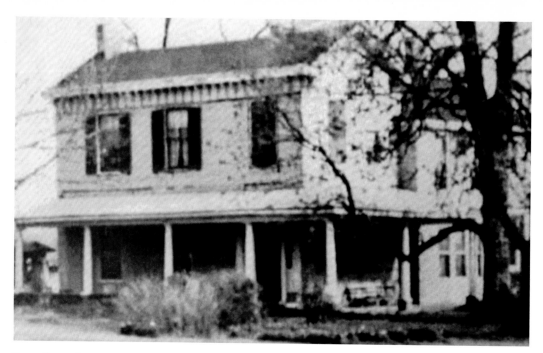

REED FARM, DIPLOMAT VILLAGE: Two generations of physicians lived in the thirty acre Reed homestead that stood the test of time until 1985. Dr. Richard Cummings Stockton Reed, the elder, was dean of the College of Medicine at the University of Cincinnati. His son, Dr. William S. Reed, spent thirty-seven years driving a horse and buggy to make house calls. He also was a thirty-five year member of the Stockton School Board, a physician for the Butler County Infirmary and Tubercular Hospital and served as health officer for Fairfield Township. In the late 1970s the family decided to sell the farm and the Diplomat Village Shopping Center was built on the site.

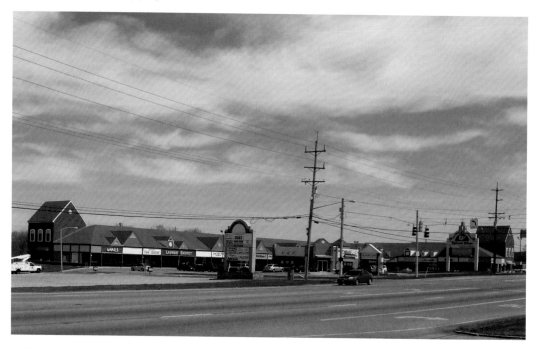

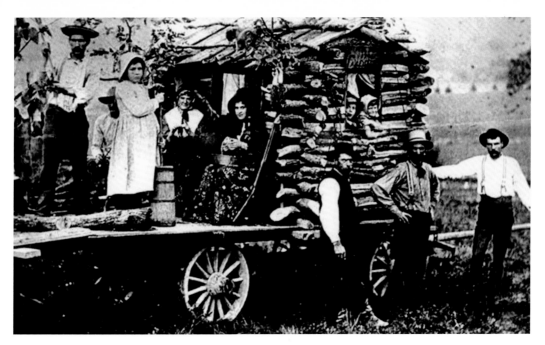

1891 HAMILTON CENTENNIAL PARADE: Fairfield Township was an award recipient as having the best representative of pioneer clearing, log cabin, coon hunting, ox wagon, and old spinning wheel and hand loom weaving ever witnessed in the Miami Valley. The float depicted a log cabin, and women in costume who churned butter, sewed and prepared fruit. Two children gazed from the window of the cabin while men with axes looked on. The parade was focused on Civil War veterans and members of the Ohio National Guard. That patriotic spirit from 1891 still exists today with Fairfield's annual Memorial Day parade that honors veterans from the five branches of services and culminates at the Veterans Memorial Park on Wessel Drive.

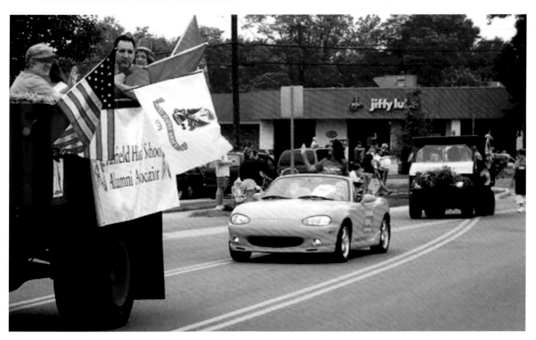

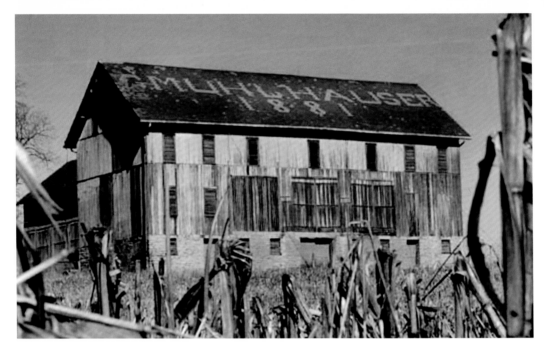

MUHLHAUSER BARN, SEWARD ROAD: The Mulhauser-Windisch Brewing Company barn was built in 1881 to store grain used to brew beer in Cincinnati. It was located near the Liberty Mutual/Ohio Casualty Group headquarters for several years before the Muhlhauser family arranged with neighboring West Chester Township to move the structure and save the barn. According to township officials, the heavy metal band Kiss used the barn for a rehearsal during its heyday. Ohio Casualty purchased the eighty-acre farm and an adjacent fifty-eight acres in 1998 before merging with Liberty Mutual. The barn was moved to Beckett Ridge Park in 2002 and has been available as a rental facility since 2008.

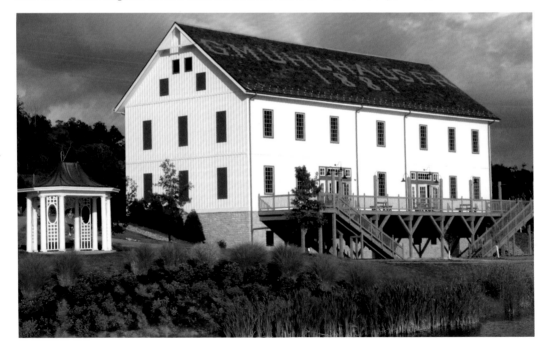

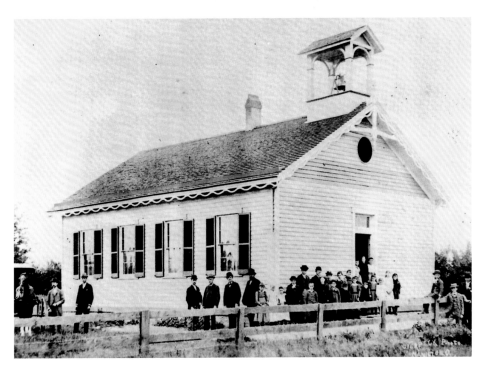

VALLEY CHAPEL CHURCH, DIXIE HIGHWAY: Established in 1866 as a Methodist church, it was reorganized in 1919 as a community church, the first one of its kind in Ohio. The beloved "Dad" Gallagher, pastor from 1926 to 1930, conducted a weekly radio program called "The Church by the Side of the Road" on radio station WRK and WMBK. Iron rings were available in nearby locust trees for worshipers to tie their horses during services. An addition was made to the church in 1952 for a classroom. In 1999 the church was physically moved back 100 feet due to the widening of Dixie Highway for a turn lane. A 4,000 square foot addition was made to the building at that time.

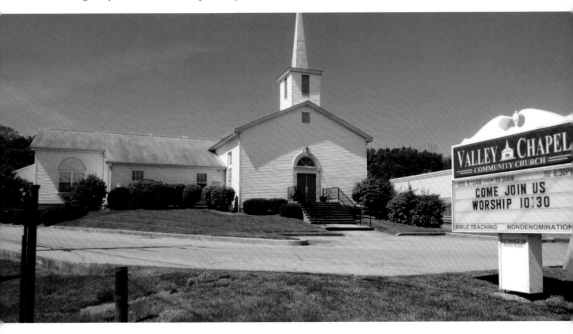

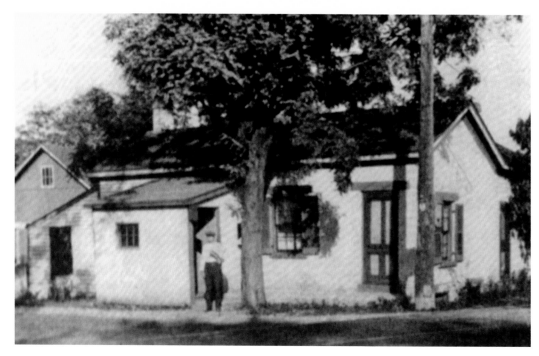

TOLL BOOTH HOUSE, DIXIE AND SEWARD ROAD: Head Shed hair styling sits on the site of the former toll booth for the Dixie Highway. The toll booth as actually a building that later served as a post office for the village of Stockton. Charles Waterhouse served as the popular and personable toll keeper and postmaster. The Head Shed moved into the building in the early 1980s after relocating from Riegert Square. The bricks of the building were originally from a brothel that operated in the early 1900s in an adjacent lot until a suspicious fire destroyed the building and ultimately the business.

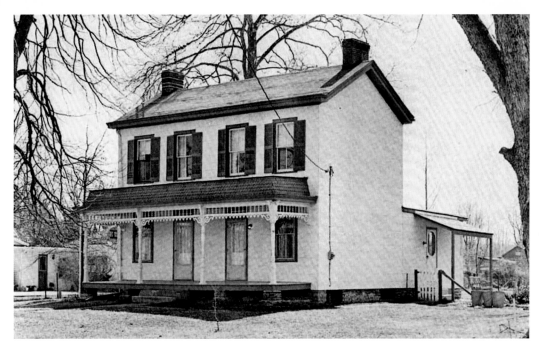

JONES STATION POST OFFICE: Oliver Treudly was the first postmaster at Jones Station in 1862, named for John D. Jones, who owned the land that the Cincinnati, Hamilton and Dayton Railroad used as a station. By 1882, confusion in the mailing address for residents arose since the post office was actually located in the village of Stockton. The Post Office requested that the railroad station name be changed to Stockton and the request was granted. This residence also served as a stop for the Underground Railroad during the Civil War. The door on left side of the building was for the post office. The door on the right lead to Treudly's residence. In 2015 the home remains subdivided into two private residences.

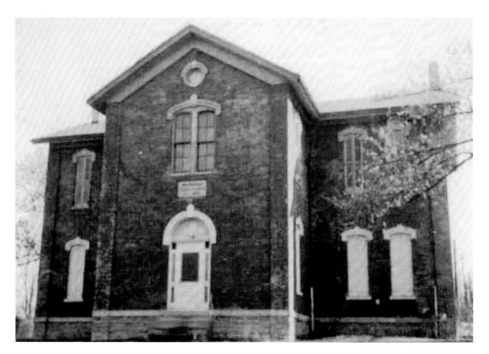

INDEPENDENT SCHOOL #1, DIXIE HIGHWAY: Built in 1878, the school operated until 1948 even after the other township schools consolidated in 1929. It contained a stage and auditorium, illuminated with kerosene lamps and built under the auspices of an independent school district provided for by an 1853 state law. The site of this school was the former site of Schoolhouse #7, according to the 1855 map of Butler County. The first building was of log construction and the seats were of split logs. In 1966, Valley Community Church purchased the building and used as a fellowship hall, kitchen, and for children's ministry, since it has a gym on the top floor.

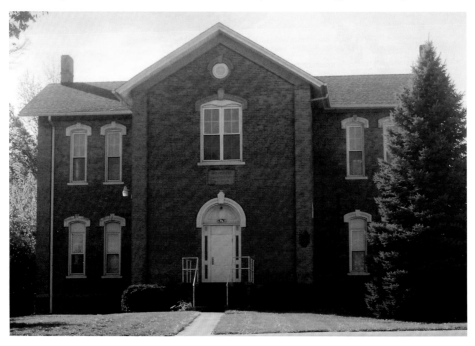

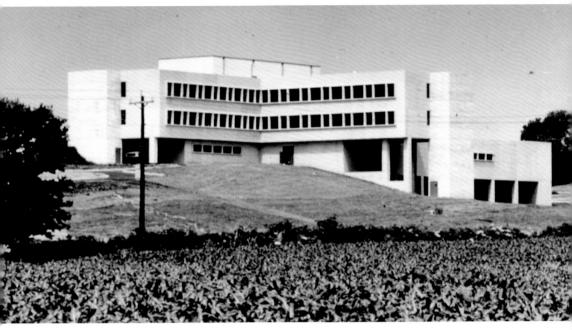

BENZING FARM, MERCY HOSPITAL FAIRFIELD: The idea for a hospital to serve Fairfield originated in 1958 when Mercy Hospital attempted to establish a facility in Glendale but the surrounding residents were not supportive. Two feasibility studies in the 1960s determined that financing was not available. In 1972 plans to establish a hospital in Fairfield got the support from the city. In August 1978, Mercy Hospital Fairfield opened on fifty acres of land originally farmed by the Mack family beginning in 1831, and later the Rudder family and George and Esther Rudder Benzing. That same year, Fairfield opened Fire Station #3 nearby on Winton Road which substantially decreased the time that medics spent transporting victims to Mercy in Hamilton or Fort Hamilton Hospital.

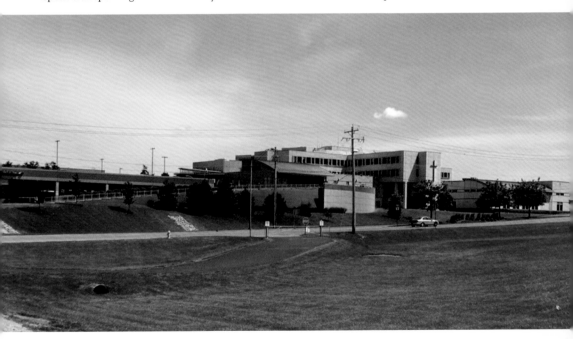

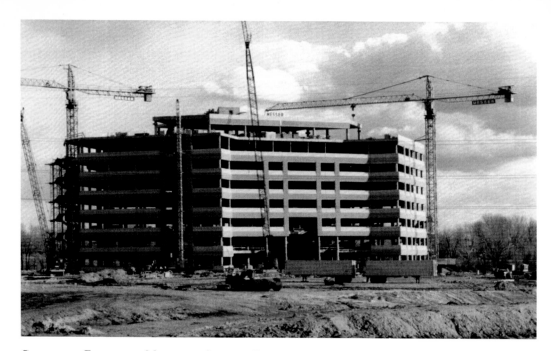

CINCINNATI FINANCIAL, MACK AND GILMORE ROADS: One of Fairfield's largest employers made the city its headquarters in 1986 with the construction of its first of three office towers. Cincinnati Financial Corporation operates a family of insurance and financial services subsidiaries including The Cincinnati Insurance Company which itself has four insurance subsidiaries. Together, The Cincinnati Insurance Company and its subsidiaries are among the nation's top twenty-five property casualty insurer groups, based on 2014 net written premiums. Cincinnati Financial Corporation ranks first among large-capital companies on Forbes' list of America's 50 Most Trustworthy Financial Companies for 2014. The second tower was completed in 2000 and the third tower opened in 2008.

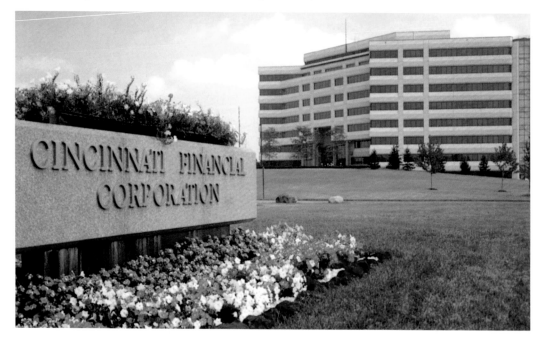